THE
WELSH
TATTOO
HANDBOOK

THE
WELSH
TATTOO
HANDBOOK

Authentic words and phrases
in the Celtic language
of Wales

by
Robert Davis and
Meagan Davis

bradan
press

Halifax, Nova Scotia

Bradan Press, Halifax, Nova Scotia, Canada
www.bradanpress.com
info@bradanpress.com

Text © 2020 Robert Davis and Meagan Davis
Front cover illustration © 2020 Pat Fish
Interior illustrations © 2020 Bradan Press Ltd.
Back cover author photo © 2020 Wren Clanton
Welsh-language editors: Angharad Devonald and Antone Minard

Excerpt from "Fy Ngwlad" © 2014 Estate of Gerallt Lloyd Owen. Courtesy of the Estate of Gerallt Lloyd Owen. "Fy Ngwlad" was originally published by Gwasg Gwynedd in 1972 in the collection *Cerddi'r Cywilydd*. Excerpts from "Tân yn Llŷn" by Plethyn © 1980 and "Yma o Hyd" by Dafydd Iwan © 1981. Reprinted by permission of Sain (Recordiau) Cyf.
Photo of Wales Millennium Centre in Figure 16 © 2020 Callum Matthews, used with permission.
Original image of Welsh dragon in Figures 8 and 14 by Llywelyn2000 from Wikimedia Commons, licensed under CC BY-SA 4.0.
Image of Welsh Love Spoon in Figure 11 by Jongleur100, image of Three Feathers in Figure 12, unattributed, image of dog paw in Figure 15 by Chris Martin, and image of Pentre Ifan in Figure 17 by LinguisticDemographer from Wikimedia Commons, public domain.
Original photo used in Figure 13 by Christopher Campbell, licensed by Unsplash.
Original photo used in Figure 17 by Rob Sarmiento, licensed by Unsplash.

Library and Archives Canada Cataloguing in Publication

Title: The Welsh tattoo handbook : authentic words and phrases in the Celtic language of Wales / by Robert Davis and Meagan Davis.
Names: Davis, Robert (Robert Neal), author. | Davis, Meagan, author.
Description: Includes index.
Identifiers: Canadiana (print) 20200305468 | Canadiana (ebook) 20200305476 | ISBN 9781988747187 (softcover) | ISBN 9781988747194 (Kindle) | ISBN 9781988747200 (EPUB)
Subjects: LCSH: Welsh language. | LCSH: Welsh language—Terms and phrases. | LCSH: Welsh language—Glossaries, vocabularies, etc. | LCSH: Tattooing. | LCSH: Words in art.
Classification: LCC PB2114 .D38 2020 | DDC 491.6/6—dc23

Printed by KDP

DEDICATION

To the one million Welsh speakers and more
of the year 2050

ACKNOWLEDGEMENTS

With heartfelt thanks to John Good and the Welsh League of
Arizona for being there at the beginning of the journey;

and to Angharad Devonald, Annette and Deian Evans,
and Antone Minard for their generous help and
guidance in writing this book. *Diolch o galon!*

TABLE OF CONTENTS

Introduction

Since you are reading this book, you are no doubt aware of the popularity and personal significance of tattoos. You may be thinking about a tattoo with a word or phrase in Welsh for yourself, or helping someone else who is. The goal may be to honour Welsh family heritage. Or perhaps you come to Welsh as a language enthusiast, expressing solidarity with one of the world's threatened minority languages, namely the one we call *iaith y nefoedd*: the language of heaven.

In any case, you now face the most important task: getting it right.

It is up to you to do your research on Welsh words, phrases, and translation before you go to your chosen tattoo artist. Wales possesses a unique culture and history. Like the other Celtic languages, Welsh is considerably different from English or other European languages. Choosing a Welsh tattoo means navigating the dangerous waters of the internet to find inspiration in a language you may not understand.

This book aims to help you choose a Welsh tattoo wisely, confidently, and safely. It offers a glossary of Welsh words and phrases

to help you. Beyond the glossary, this book provides enough of an introduction to the Welsh language to support you in your desire to honour it. You may even be interested in learning how to join the hundreds of thousands of people who speak it.

The Welsh language has been suppressed for much of its history. It was thought to be uncivilized. Children were punished for speaking it in school. Even today, the language is fighting for its life. Yet it is a language of great beauty and power, known for its stunning heritage of poetry and music. As one famous song says, despite everyone and everything, like the Welsh people themselves, the language is *yma o hyd* (still here).

This book suggests Welsh words and phrases. **This book does not give examples of tattoo artwork.** However, Chapter 3 provides examples of some popular Welsh symbols that may be of interest. Once you have decided what your tattoo should say in Welsh, and whether it will incorporate any Welsh symbols, you can work with your preferred artist to create the perfect design.

Chapter 1
What is Welsh?

Welsh, the language of Wales, is the most widely-spoken member of the Celtic language family. There are more than 500,000 speakers in Wales. So, why do people outside of Wales react with confusion to the statement "I speak Welsh"? The truth is a complicated brew of politics, oppression, and migration. Before we address common questions and concerns about using the Welsh language in a tattoo, let's take a look at some background on the language itself, starting with its rich history and the state of the language today.

A Brief History of the Language

The Celtic languages are a different language family from both the Romance languages and the Germanic languages. The Celtic languages are the native languages of the geographical areas now called the British Isles, and Brittany in the northwest of France. They are divided into two branches: Goidelic and Brythonic. The modern languages of the Goidelic branch are Scottish Gaelic, Irish, and Manx. The modern Brythonic languages spoken in the 21st century are Cornish, Breton, and Welsh (see Figure 1 on the following page).

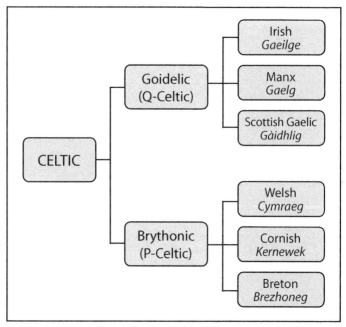

Figure 1: The modern Celtic language family

The Welsh language has a rich history of poetry and song, beginning with epic tales and myths passed down orally, then blossoming into a flourishing written tradition. Ancient poets like Taliesin and Aneirin still hold high status in Welsh culture, nearly 1500 years after they praised the heroic deeds of the 6th century CE. Some of the ancient bardic traditions can be seen reflected today in competitions like the National Eisteddfod, in which the Welsh compete in poetry, prose, song, instrumental music, and other arts. The Eisteddfod is basically the national Olympics of the arts, with the most important "medal" being awarded in formal verse. That's how serious this country is about poetry. As the old saying has it: *Cenedl heb iaith, cenedl heb galon* (A nation without a language is a nation without a heart).

One of the important early Welsh-language works is *Pedair Cainc y Mabinogi*, or "Four Branches of the Mabinogi," a collection of Welsh myth and narrative tradition compiled in the 11th century CE. A later compilation of those stories and others became famous as

the Mabinogion we know today. The earliest known surviving Welsh-language manuscript is *Llyfr Du Caerfyrddin* (The Black Book of Carmarthen). About the size of a modern mass-market paperback book, it dates from the 13th century CE, and includes poems relating to two famous figures of legend: Arthur and Merlin. This heritage of Welsh mythology is worthwhile to look into as a potential source for tattoo inspiration, as we will discuss in Chapter 3.

For centuries Wales was divided into a number of small, rural kingdoms, but occasionally an ambitious ruler would succeed in dominating the others. One of the greatest of these Welsh rulers was the king Hywel Dda (Hywel the Good), known especially for the legal code that bears his name. Welsh law of the time was comparatively liberal about fair restitution, equitable division of property, divorce, and the rights of women.

Though William of Normandy successfully invaded England in 1066, Wales mostly managed to fend off the Normans through both battle and negotiation (see Figure 2 on the following page for a map of modern Wales). However, a crucial turning point for the Welsh language came in 1282, with the death of Llywelyn ap Gruffydd and the conquest and annexation of Wales by Edward I of England. Thus began centuries of linguistic oppression.

When England gained legal authority over the people of Wales, English became the official language of government and legal proceedings. The Welsh language was thought to be uncivilized, never mind its rich literature or the sophisticated legal code that had been in place for hundreds of years. Although the coronation of Henry VII in 1485 would eventually initiate the Tudor dynasty with a king of Welsh descent, Wales itself saw little benefit. Over the centuries of English rule, Wales was treated as a poor backwater.

In the 18th and 19th centuries, the Industrial Revolution and the British Empire brought huge demand for Welsh coal, which came to define the country's image. Many thousands went to work in the mines, even young children. The resulting wealth left Wales as quickly as trains and ships could carry it, however. The 1800s saw multiple uprisings by working-class Welsh people to demand justice, including the Merthyr Rising and the Chartist movement.

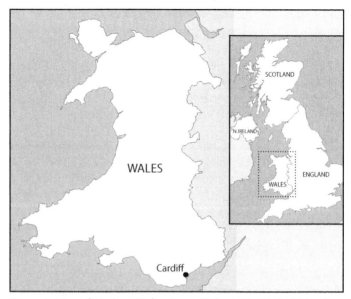

Figure 2: Map of Modern Wales. Inset: Wales in the United Kingdom

The government violently suppressed such revolts, with many protesters killed or imprisoned.

In 1847, English education commissioners published a report on the state of education in Wales. This report, now referred to as *Brad y Llyfrau Gleision* (The Treachery of the Blue Books), declared the Welsh language a great hindrance to progress in the country. Of course, as the English commissioners spoke no Welsh, their report primarily reflected the imperialist opinions of the English-speaking elite.

These prejudices were symbolized by the "Welsh Not," a piece of wood or lead on a rope hung around a student's neck as a punishment for speaking Welsh. If another student was caught speaking Welsh, the Not was handed off to them. The student wearing the Not at the end of the day faced a beating or other punishment.

The Welsh language has experienced a long decline as a result of this historic oppression. By 1911, Welsh had become a minority language in Wales, spoken by just 43.5% of the population.

The Welsh Tattoo Handbook

The proportion of speakers continued to fall, reaching an all-time low of 18.7% per the 1981 census.

By the middle of the 20th century, numerous political and language activists fostered a renewed spirit of Welsh identity. The poet Saunders Lewis gave a speech on the radio in 1962 called "Tynged yr Iaith" (The Fate of the Language) predicting the eventual extinction of Welsh. His impassioned speech inspired many to take action to save the Welsh language. Following decades of struggle, the passage of the Welsh Language Act of 1993 finally placed Welsh on equal footing with English as an official language in Wales, and ensured that its use would be protected.

Following the establishment of the National Assembly for Wales in 1999 and the devolution of powers to the Welsh government, efforts to expand the use of Welsh and grow the number of Welsh speakers have included primary and secondary education through the medium of Welsh, language programs for adult learners, bilingual public signs, and the legal rights to fill out forms, plead court cases, and do business with the government in Welsh. In 2020 the Assembly changed its name to Senedd Cymru, the Welsh Parliament.

The State of Welsh Today

The Welsh government has declared a goal of one million speakers by the year 2050. New Welsh-medium schools are opened each year due to increasing demand. Courses for adult learners at any level are now widely available. *Cam wrth gam* (step by step), Wales is making progress toward its goal.

The primary hurdle for growing the Welsh language community is economic. The coal industry was the lifeblood of the country in the 19th and 20th centuries, but is no more, thanks to the shift to oil and natural gas fossil fuels. The areas of Wales with the highest concentrations of Welsh speakers tend to be rural, meaning that younger speakers often move away to find work. Like other largely rural countries, Wales faces the challenge of a "brain drain," hindering the recovery of the language within Wales.

At the same time, ironically, the beauty of Wales makes it a popular retirement or second-home destination for people from outside the country. The competition for limited housing has priced many Welsh people out of the housing market in popular areas, and many of the English-speaking newcomers are not interested in learning Welsh.

In the end, despite its many challenges, the Welsh language persists. Of course, Welsh can always use one more person toward its goal of one million speakers! There are many opportunities available for online or in-person learning, as well as books to help you along the way, and we will be pleased to point you to some of them in the pages ahead. *Dal ati!* (Keep at it!) As we continue, we'll also talk about some important aspects of Welsh as a living language.

The Bardic Tradition

The bardic tradition of Wales offers an inexhaustible source of tattoo possibilities. Wales prizes its literary heritage, seeing itself as a nation of bards. Cultural festivals celebrating poetry and music, called *eisteddfodau*, take place all over the country. The biggest one of all is Eisteddfod Genedlaethol Cymru, the National Eisteddfod of Wales, which awards prizes for the greatest achievements in Welsh literature each year. The competition is anonymous, with entries being submitted under pseudonyms. The identity of a victorious bard is unknown until he or she stands up to be recognized after the winning entry is announced.

The top prize is called *y Gadair* (the Chair). A new, full-size, carved wooden chair, similar to a throne, is designed and crafted each year to be awarded to the bard who submits the greatest new work using traditional Welsh poetic forms (see Figure 3). If the judges believe the standard of entries is not high enough in a given year, the Chair will not be awarded.

The key to creating praiseworthy traditional Welsh poetry is the use not only of traditional verse forms and meters, but also of *cynghanedd*, the Welsh system of alliteration and vowel harmony. It is not the same thing as rhyme, although Welsh poetry does

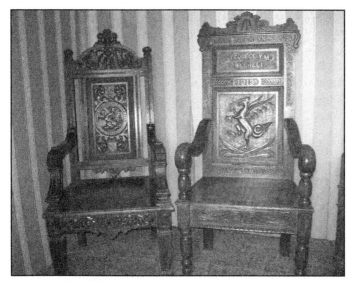

Figure 3: Eisteddfod Chairs awarded to Hedd Wyn (see Chapter 3)

use rhyme. *Cynghanedd* involves formal standards for the repetition of consonants and for different types of vowel agreement. A complete explanation of the different types of *cynghanedd* is beyond the scope of this book, but an example from the glossary in Chapter 6 will give a flavour of the possibilities:

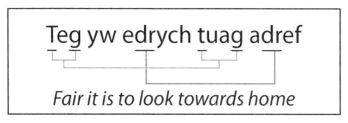

Figure 4: An example of *cynghanedd*

Note the repetition of consonants in the two halves of the line. The *t* and *g* of *teg* are echoed by the *t* and *g* of *tuag*. The *d* and *r* of *edrych* are echoed by the *d* and *r* in *adref*. In this case the *ch* of *edrych* and the *f* of *adref* are ignored; different types of *cynghanedd* follow various rules and patterns.

Exploring the bardic tradition of Wales and finding a verse of Welsh poetry that speaks to you can be a path to a much more meaningful Welsh tattoo idea, a more culturally resonant idea, than just translating something that sounds good in English. Some are mentioned in the glossary in Chapter 6, but we have barely scratched the surface in this book. We encourage you to explore further.

In the following chapter, we'll look at some of the features of Welsh that give the language its unique structure and flavour.

Chapter 2
Features of the Welsh Language

Now that you know a little about the place of the Welsh language in history and culture, it's time to talk about the language itself. This chapter covers a few important basics, including different forms of the language, the Welsh alphabet and how it differs from the English alphabet, Welsh word order in sentences, a Celtic grammatical feature called "consonant mutation," and the concept of grammatical gender. This should help you avoid some of the most common spelling and grammar mistakes in planning your Welsh tattoo.

Everyday Welsh vs. Literary Welsh

As with other languages, Welsh can be written and spoken in different versions, depending on where and how it is being used. These versions are called "registers." Different Welsh registers are used in different kinds of speaking and writing, for example in religious services, television and radio broadcasting, novels, journalism, texting, conversations in the pub, and so on. For the most part, there are two widely acknowledged registers of Welsh that could be relevant for the purpose of designing tattoos: Literary

Welsh, mostly used in formal writing, and Colloquial Welsh, used in everyday conversation.

The differences between Literary and Colloquial Welsh are much greater than the differences between formal, literary English and colloquial, everyday English. In some ways, Literary and Colloquial Welsh almost feel like different languages. There are significant differences in sentence construction and word choice. Figure 5 provides some examples of Literary Welsh entries from the glossary, and compares them to a few possible colloquial variations. Mixing Literary and Colloquial registers tends to sound confusing and weird, so it is important to consider the spirit and tone of an intended tattoo in Welsh, and match it to the most suitable register.

Traditional proverbs, Biblical quotations, hymns, and poems are all written using Literary Welsh. Often they use unfamiliar grammatical features and archaic vocabulary that would be unheard of in spoken, Colloquial Welsh. The upside of this is that Literary Welsh is astonishingly beautiful, lending itself to mellifluous rhythms and alliteration. So, if you want a tattoo of the 23rd Psalm from the Bible, for example, it's definitely worth looking at the version in an old William Morgan translation circa 1588, or the 1620 revision. While there are more modern, even colloquial, Bible translations

English	Literary Welsh	Colloquial Welsh
I came, I saw, I conquered	Deuthum, gwelais, gorchfygais	Des i, gweles i, a nes i goncro
Persistent tapping breaks the stone	Dyfal donc a dyr y garreg	Mae tapio'n ddyfal yn torri'r garreg
Fair it is to look towards home	Teg yw edrych tuag adref	Mae edrych tuag adre yn deg
All that glitters is not gold	Nid aur yw popeth melyn	Dyw popeth melyn ddim yn aur

Figure 5: Examples of glossary entries written in Literary vs. Colloquial Welsh

The Welsh Tattoo Handbook

available, the Literary Welsh of 400-plus years ago still retains its artistry and impact, much like the King James Version of the Bible does for many English speakers today. The glossary in Chapter 6 contains examples of traditional proverbs and Bible verses in Literary Welsh.

In contrast to Literary Welsh, Colloquial Welsh is the register of everyday, spoken Welsh. It is also used in informal writing. A broadly-agreed standard for modern Colloquial Welsh is used in teaching the language today. However, if you have a particular regional connection to Wales, for example if you want a tattoo to honour family history, then regional dialect variations may be something you want to incorporate in a tattoo using Colloquial Welsh.

Welsh Dialects

Like all languages, Welsh contains significant regional variation in dialects. Different dialects may use different words, pronounce the same words differently, and even modify grammar. Although features from multiple dialects are naturally and widely mixed across Wales, there is a broad consensus that Welsh has two main dialects—a northern variety ("North Walian") and a southern one ("South Walian"), although no firm border can really be drawn between them, and in mid-Wales they mix in interesting ways.

People from North Wales are affectionately referred to as *Gog*s, which comes from the Welsh word for the north, *y Gogledd*. Those from the south are often known as *Hwntw*s, which may be a corruption of the phrase *tu hwnt*, meaning "beyond." In Welsh language learning, people may choose to learn the dialect of a particular region. For tattoo purposes, the most likely impact of dialect will be in the use of special regional vocabulary.

Once in a while these dialect differences can lead to miscommunication. An acquaintance of ours from the Rhondda valley in South Wales told a funny story about being offered tea by a woman from the north. The woman asked him if he wanted milk with his tea, and used the northern word for it: *llefrith*. The southern word for "milk" is *llaeth,* but everyone knows both words, so there's no real

reason for any misunderstanding—except that in this woman's particular accent, the word *llefrith* struck his South Walian ear as *llofrudd*, and for a moment, until her true meaning had a chance to register, he found himself quite taken aback as to why she was offering him a murderer with his tea!

The variety of Welsh dialects is too vast to describe fully here. The glossary in Chapter 6 makes note of expressions with regional variations where they occur. Welsh-English dictionaries will generally point out which versions of words are typically used in North or South Wales.

The Welsh Alphabet

The Welsh alphabet is similar to the English one, in that both are written in the Latin script and share many, but not all, of the same letters. The Welsh alphabet has 28 letters, but omits J, K, Q, V, X, and Z. Figure 6 shows the letters of the Welsh alphabet and the sounds they make.

As you can see, in Welsh there are a number of cases where a double consonant counts as a single alphabet letter and sound. These are part of the unique look and sound of the Welsh language. The Welsh government has even commissioned a family of fonts called "Cymru Wales" to better reflect the uniqueness of the Welsh language and its orthographic history.

Welsh Word Order

Welsh sentences follow the word order of Verb–Subject–Object (VSO), as do the other Celtic languages. This is different from the typical English sentence word order of Subject–Verb–Object (SVO). For example, an English sentence like "I am reading a book" is translated into Welsh as *Dw i'n darllen llyfr*, which word-for-word says "Am I reading book." Breaking down this sentence, "am" is the verb, "I" is the subject, and "book" is the object (the indefinite article "a" is not there because it is not a separate word in Welsh; it is implied with the noun).

Letter	Pronunciation
A	long ah as in ball or short ah as in cat
B	b as in bat
C	c as in cat
Ch	ch as in Bach
D	d as in dog
Dd	hard th as in thee or that
E	eh as in let
F	v as in violin
Ff	f as in fat
G	g as in gas
Ng	ng as in bang
H	h as in hat
I	ih as in bit, or ee as in keep
L	l as in lace
Ll	place the tip of your tongue behind your top front teeth and blow; similar to an h and an l together
M	m as in milk
N	n as in noon
O	oh as in more (in British English)
P	p as in pat
Ph	soft f as in fall
R	r as in rap
Rh	while making a regular r sound, make a breathy h sound
S	soft s as in sand
T	t as in taste
Th	soft th as in bath
U	usually ee as in keep, sometimes ih as in sit
W	w as in war, oo as in book, or oo as in broom
Y	ih as in bit, ee as in beet, uh as in fun

Figure 6: The Welsh alphabet

However, in Welsh the word order can also be switched around to emphasize a particular part of the sentence. For example, the sentence in the previous paragraph can be rearranged to read: *Llyfr ydw i'n ei ddarllen*, literally "Book am I its reading." Basically, this means "A book is what I'm reading (not something else)." Because many proverbs and quotations have literary origins, you will see a lot of this style used for poetic effect in the glossary—although it's worth noting that the same thing can also be done in Colloquial Welsh.

It's Mutating!

For English speakers, one of the wildest and weirdest features of Celtic languages is the tendency for the first letter or sound of a word to change based on a number of grammatical factors. This feature is called "mutation." Although it's actually governed by a set of invisible grammar rules, the explanation we've heard for this phenomenon from Welsh speakers is "It just sounds better that way"! You need to know about it because you will want your Welsh tattoo to be spelled correctly, and mutation affects the way that many words are spelled when you combine them into phrases. The grammar of the phrase dictates how the spelling of the word will change—but dictionaries don't always point this out in their word entries. This is a major reason why you should never attempt your own translation by looking up the individual words of an English phrase in a Welsh dictionary.

There are three types of mutation in Welsh: soft, nasal, and aspirate. Soft mutation is the most common, and happens in a great many cases. Words that undergo soft mutation include feminine singular nouns after the word "the" (*y/yr/'r*), adjectives following feminine singular nouns, words following the majority of prepositions, direct objects following inflected verbs, and predicate nouns or adjectives after *yn*. Nasal mutation is less frequent, but reliably happens after the preposition *yn*, meaning "in," and after the possessive fy meaning "my." Aspirate mutation is the least common and the most often omitted in colloquial speech, but typically occurs after the possessive *ei* meaning "her" and after the conjunction *a* meaning "and," and is also used in negation. This may sound incredibly complicated, but fear not—the glossary

entries have already dealt with the mutations for you, and you can refer to Chapter 4 of this book, "Tattoos Lost in Translation," for more examples. Figure 7 shows a few examples of mutation in action from the glossary, with the words undergoing mutation shown in **bold**.

Gender

Grammatical gender matters for your tattoo because it affects the spelling and pronunciation. There's no need to worry, however. The glossary entries in Chapter 6 include the correct grammatical gender distinctions where relevant.

Much like French, Spanish, and German—but unlike English— Welsh assigns a gender to all nouns in its grammar. Also like French, Spanish, and German, there is no real rhyme or reason to this assignment, at least for a language learner. It's one of those things you stumble around with at first, but eventually you'll get a feel for it. Fortunately, Welsh is easier in this regard than many languages. In German, for instance, there are three grammatical genders—masculine, feminine, and neuter—and they have nothing to do with people's sex or gender identification. A famous example from German is *das Mädchen*, "the girl," a word which is actually grammatically neuter rather than feminine. In Welsh, if a

Dictionary form	Used in a phrase	Type of mutation
Goddess *Duwies*	The Goddess *Y **Dduwies***	Soft mutation
Step *Cam*	Step by step *Cam wrth **gam***	Soft mutation
Brother *Brawd*	My brother *Fy **mrawd***	Nasal mutation
Father *Tad*	Her father's daughter *Merch ei **thad***	Aspirate mutation

Figure 7: Examples of Welsh words undergoing mutation

word refers to a person or role that is gendered in society, then the grammatical gender matches it: *mam*, "mother," is grammatically feminine, while *tad*, "father," is masculine. Some languages, like German or English, have a gender-neutral word for "it." Welsh, on the other hand, generally defaults to the feminine *hi*, "she," when it is not obvious which noun is being replaced by "it." An example would be in the phrase "It's raining," *Mae hi'n bwrw glaw*. Sometimes, Welsh even leaves the pronoun "it" out entirely.

You'll mostly notice grammatical gender in Welsh because of feminine singular nouns, which cause adjectives following the noun to mutate, and which themselves mutate after "the" *(y/yr/'r)*. There are also different forms of some numbers and adjectives depending on the gender of the object you're counting or describing: the word "two" referring to two masculine gendered objects is *dau*, while the word for referring to two feminine gendered objects is *dwy*. The differences continue for "three" *(tri/tair)* and "four" *(pedwar/pedair)*, as well as some words like "strong" *(cryf/ cref)*, "short" *(byr/ber)*, and others.

To avoid mistakes in grammatical gender when choosing a Welsh word or phrase for a tattoo or inscription, be sure to pay attention to any distinctions noted in the glossary in Chapter 6.

Chapter 3
Choosing a Welsh Tattoo

The Welsh language and culture are much more than just words in a dictionary or dates in a history book. Important Welsh symbols, historical figures, poetry, music, and cultural concepts can be combined with Welsh words and phrases to make beautiful and culturally meaningful tattoos. The sections of this chapter describe some of these well-known aspects of Welsh culture that developed along with the language itself.

Popular Welsh Symbols

Following are some popular symbols of the country of Wales, the Welsh people, and their spirit and customs, which could be used in a tattoo design.

The Dragon

One of the most recognizable Welsh symbols is the red dragon or *y ddraig goch*, which adorns the Welsh flag (and the cover of this book!). Wales is one of a lucky few countries to have a mythical creature as its emblem (see Figure 8).

The story of the dragon goes as far back as the *Mabinogion*, an early collection of Celtic myths and legends (see Chapter 1), and the *Historia Brittonum*, a 9th-century history of the original inhabitants of Britain. In these ancient stories, the red dragon fought a white dragon and prevailed. This may represent the ancient Britons who were not defeated by invading Saxons and ultimately became the Welsh.

King Henry VII (1457–1509) used a red dragon on a field of green and white as his banner, after which the dragon was used on the Tudor coat of arms to indicate the Welsh heritage of the Tudor dynasty. (The Tudor name comes from the Welsh name *Tudur*.) The red dragon on a green and white field became the national flag of Wales in 1959.

The Daffodil

The daffodil or *cenhinen Bedr* (St. Peter's leek) is the national flower of Wales (see Figure 9). Its resemblance to the leek, as well as having that word in its Welsh name, is believed to be the origin of its connection to Wales, which was not popularized until the 19th century. It also happens to bloom around the time of year that St. David's Day occurs, on March 1st. This holiday celebrates St. David (*Dewi Sant*), the patron saint of Wales, and daffodils are often worn to mark the day.

The Leek

By far the tastiest Welsh symbol, the green and white vegetable from the onion family called the leek has long been associated with Wales (see Figure 10). Legend has it that Cadwaladr, king of Gwynedd in the 7th century (or, as some tell it, St. David himself) had his men wear leeks in their hats into battle so that they could easily identify each other. The leek is another symbol often worn on St. David's Day, a custom mentioned by Shakespeare in the play *Henry V*.

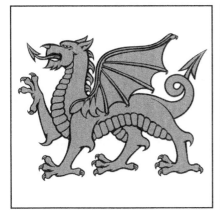
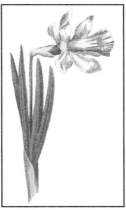
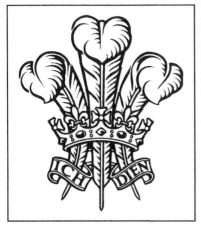

Figures 8–12, clockwise from top left:
Figure 8: The Welsh dragon
Figure 9: The daffodil, a symbol of Wales
Figure 10: The leek, a symbol of Wales
Figure 11: A Welsh love spoon
Figure 12: Three feathers, a symbol of the Prince of Wales

The Love Spoon

According to tradition, a Welsh lad who wished to woo a lady would create a carved wooden spoon to give her as a symbol of his love (see Figure 11). A spoon may not sound terribly romantic, but the intricate designs carved into the handle and bowl of the spoon all have special meanings: a heart for love, a dragon for protection, a cross for faith. Love spoons are popular Welsh souvenirs and gifts to commemorate particular milestones in a relationship. They often hang on the walls of Welsh homes.

The Three Feathers

This symbol, three feathers bound together by a crown, is a subject of controversy, as it technically represents not Wales itself, but the Prince of Wales, a title now given to the heir to the British throne (see Figure 12). Prince Charles has been the Prince of Wales from 1958 until the time of writing this book, and although he studied some Welsh and attempted to deliver some remarks in Welsh at his investiture, contemporary Welsh folk song is not known for being terribly fond of him. On the other hand, the three feathers are also used by Welsh units of the British Army, and by the Welsh national rugby team. Additionally, in British Sign Language the sign for Wales is derived from the appearance of the three feathers. The symbol therefore could be said to represent a history of conquest and oppression, or of national pride. Symbols can hold different and even conflicting meanings for different people and groups, and this is part of what makes them so powerful.

Christian Religious References

Wales has a deep heritage of Christianity, for those interested in a Christian religious tattoo. The history runs so deep that in the 12th century the Pope himself rated two pilgrimages to the beautiful St. Davids Cathedral in southwest Wales as having the same worth as a pilgrimage to Rome, and three pilgrimages to St. Davids as equivalent to a pilgrimage all the way to Jerusalem. St. Davids remains a place of pilgrimage even today, and St. David's Day (the national holiday of Wales) is celebrated on March 1st.

Who was St. David? He is recognized as the patron saint of Wales, and is the only patron saint of the British Isles to originate in the country of his patronage. In comparison to some saints of a more mythic stature, his life in the 6th century CE is reasonably well-attested. He was widely respected, founded numerous churches and monasteries, and advocated living a simple life. The cathedral that bears his name stands on the site of one of his monastic communities, founded 600 years before the cathedral was built. His final, humble words to his followers are still remembered today, and are good advice for anyone: *Gwnewch y pethau bychain.* (Do the little things.)

Historically, the Christianity practiced by speakers of the Celtic languages included multiple diverse church traditions that developed independently from dominant Roman Catholic traditions. Carvings and other art created by early Christians in the British Isles reflect this uniqueness. The Celtic Church developed its own "insular" or island style, drawing on, yet distinct from, the early Christian art of continental Europe. One of its most recognizable features is the Celtic cross, found carved in stone across Celtic landscapes. It differs from the typical cross in that there is a ring, called a "nimbus," around the point where the arms intersect. Numerous variations of these crosses exist in Celtic art, and could be inspiring elements in a Welsh-language tattoo. Beware of one variant with straight black arms of equal length on a red and white field resembling the Nazi flag, which was designed and adopted by certain racist hate groups. It is offensive and tragic to see this abuse of a Celtic symbol of faith. Appreciation of Welsh art, culture, heritage, and religions is open to all, regardless of origins or ethnicity.

The Welsh language offers a rich tradition of composing and singing Christian hymns. Numerous Welsh hymns are popular in Wales even beyond religious settings. Especially in an English translation widely known as "Bread of Heaven," the hymn "Cwm Rhondda" is now a ubiquitous Welsh rugby anthem. Many other hymns are part of the repertoire of the countless choirs, most notably the traditional male voice choirs, which fill the country. Meaningful verses or phrases taken from hymns and other songs offer rich tattoo inspiration. On the following page are the opening verses from two famous Welsh hymns, with English translations.

Cwm Rhondda

Text by William Williams Pantycelyn, 1762

Arglwydd, arwain trwy'r anialwch,
Fi, bererin gwael ei wedd,
Nad oes ynof nerth na bywyd,
Fel yn gorwedd yn y bedd;
Hollalluog, Hollalluog
Ydyw'r Un a'm cwyd i'r lan,
Ydyw'r Un a'm cwyd i'r lan.

Lord, lead through the desert,
Me, a pilgrim of miserable countenance
In whom there is neither strength nor life,
As one lying in the grave;
Almighty, Almighty
Is the One who lifts me up,
Is the One who lifts me up.

Calon Lân

Text by Daniel James (Gwyrosydd), circa 1890

Nid wy'n gofyn bywyd moethus,
Aur y byd na'i berlau mân;
Gofyn wyf am galon hapus,
Calon onest, calon lân.
Calon lân yn llawn daioni
Tecach yw na'r lili dlos;
Dim ond calon lân all ganu,
Canu'r dydd a chanu'r nos.

I don't ask a luxurious life,
The world's gold nor its fine pearls;
I ask for a happy heart,
An honest heart, a pure heart.
A pure heart full of goodness
Is fairer than the lovely lily;
Only a pure heart can sing,
Sing by day and sing by night.

We have provided these translations, but note that it is important to be cautious with any other hymn translations you find, if you are looking for a suitable Welsh phrase. Many Victorian-era English "translations" of Welsh hymns are not translations at all, but at best loose adaptations, or even completely unrelated material!

Welsh Historical Figures

The Welsh are proud of their long and distinctive history. Following are a few brief descriptions of some notable figures from Welsh history. Knowing a bit about them, their symbols, and their historical reputations may provide inspiration for your Welsh tattoo, or give you a new angle to research as you develop your ideas.

Hywel Dda

Hywel Dda ("Hywel the Good") was a Welsh king of the 9th and 10th centuries who eventually came to rule over much of the country. He is known for his legal code Cyfraith Hywel (Hywel's Law), which by the standards of the time was thought to be notably sensible and compassionate. It is the respect for his wise rule and law that earned him the epithet "the Good." His legal code was superseded when Wales was annexed by England, but an office building in Cardiff for members of Senedd Cymru, the Welsh Parliament, still bears his name: Tŷ Hywel (Hywel's House).

Llywelyn Fawr

Llywelyn Fawr, or Llywelyn the Great, was a great Welsh king famous for uniting much of the fractious country under his rule. He even signed a treaty with King John of England and cemented the alliance by marrying John's daughter, Joan. Unfortunately, following his death in 1240, the situation deteriorated to the point that Wales was finally conquered by England in 1282. Llywelyn's status as ruler during a great period of freedom and stability has earned him a place in many Welsh works of literature and poetry.

A touching legend of Llywelyn Fawr is that of his faithful dog Gelert. According to the tale, Llywelyn went out to hunt, leaving

Gelert to guard his young child. While the king was away, a wolf attacked his home, and Gelert killed the wolf in defense of the child. Tragically, upon his return, seeing Gelert covered in blood, Llywelyn assumed the worst, and slew Gelert on the spot. Moments later he found the dead wolf and the unharmed child, and was supposedly so grieved by what he had done that he never smiled again. A monument to the legendary canine stands in the town of Beddgelert, which translates to "Gelert's Grave."

Owain Glyndŵr

Owain Glyndŵr is acknowledged to be the last Welshman to hold the title "Prince of Wales." A descendant of several different Welsh royal families, he mounted the Welsh Revolt against Henry IV in 1400. Though the revolt ended in defeat, he was never captured. There are numerous myths and legends regarding his disappearance in 1412 and potential progeny. He continues now as a symbol of Welsh nationalism and as the epitome of the tragic Welsh hero. His banner, Y Ddraig Aur (the Golden Dragon), is still flown in honour of his fervent patriotism.

Jemima Nicholas

There's a bit of a stereotype in Wales about what's known as the "Welsh *mam*," or Welsh mother. It's a fairly typical matriarchal image, honouring the figure of hard-working, self-sacrificing, stern-but-loving motherhood. However, in Wales this traditional image is seasoned with a bit of an edge, similar to how we might see a "mama bear" today. The renowned Jemima Nicholas is a paragon of this image, as she protected her country as fiercely as any Welsh *mam* could do. In 1797, a small French force attempted to invade Britain by landing in Wales. The attempt lasted only a few days, during which many of the soldiers seem to have occupied themselves with looting and getting drunk. However, Jemima Nicholas is remembered to this day for her part in repelling the invasion. Armed with nothing but a pitchfork and her righteous indignation, Jemima single-handedly captured twelve French soldiers and locked them in a church.

Welsh Mythological Figures

As mentioned in Chapter 1, Wales has a deep history of unique myth and legend. Some of its notable figures, such as Myrddin, who you may know as "Merlin," have crossed over into English-language popular culture, albeit in altered form. Others have not enjoyed such crossover appeal. In this section we provide just a few examples of interesting human and divine figures from Welsh mythology who could be an inspiration for your tattoo design.

Ceridwen

Appearing in a number of ancient Welsh texts, Ceridwen is known for her magical cauldron of inspiration. In the *Tale of Taliesin*, she created a potion in the cauldron by which she intended to provide her ugly son Morfran with the gift of wisdom. However, Gwion Bach, a young boy she asked to stir the concoction, accidentally drank it instead. After a complicated chase involving Ceridwen and Gwion turning into lots of different animals, Ceridwen ate Gwion, and subsequently gave rebirth to him in a new form: the famous Welsh poet Taliesin.

Rhiannon

Rhiannon is a savvy and beautiful woman appearing in the Four Branches of the Mabinogi, often rebuking foolish men. She first appears riding a white horse, and she and her son Pryderi are often portrayed as a mare and foal. Pryderi is kidnapped shortly after birth, and Rhiannon is framed for infanticide, sentenced to sit at the gate of her city and act as a beast of burden for travelers. She is later exonerated when her son is found alive.

Blodeuwedd

In the Four Branches of the Mabinogi, Blodeuwedd (whose name means "Flower-faced" in Welsh) is created by two sorcerers, Math and Gwydion, using the flowers of oak, broom, and meadowsweet, as an answer to a curse placed upon a man named Lleu Llaw Gyffes to prevent him from marrying any human woman. Blodeuwedd is later turned into an owl as punishment for attempting to murder her husband.

Myrddin

Myrddin—or Merlin, as he is known among English speakers—is one of the more well-known Welsh mythological characters primarily because of his appearance as a wizard in Arthurian legends compiled by Geoffrey of Monmouth (c. 1095–c. 1155). However, in poems from the *Llyfr Du Caerfyrddin* the character of Myrddin is presented as a bard gone mad in the forest, talking to a tree and a pig, and foretelling the outcome of battles with Norman invaders.

Welsh Poetry

Innumerable Welsh poems offer potential tattoo inspiration. Many of these can be found online, but the translations offered alongside them are not always reliable. The Welsh poetic sensibility is substantially different from the English one, and attempts to translate Welsh poetry into "good" English verse are rarely satisfying. It is therefore wise to seek assistance from a Welsh speaker and/or a competent translator, to be sure that you understand a particular poem, or else to locate a suitable poem on a theme of interest to you.

Noteworthy poets writing in Welsh span the millennia. Taliesin is an especially famous name that comes down to us from the 6th century CE. His name may sound familiar today because Frank Lloyd Wright, the famous US architect of Welsh ancestry, used it to name his two compounds in Wisconsin and Arizona. The early medieval bard Aneirin gave us *Y Gododdin*, a collection of elegies to fallen warriors. The later medieval bard Dafydd ap Gwilym is renowned for his love poetry, which is not only romantic but also humorous and bawdy. Moving into the modern era, the great hymn writer William Williams Pantycelyn wrote in the 18th century (the aforementioned "Cwm Rhondda" was one of his). In the 19th century, Evan James wrote the words for a song that would ultimately become the Welsh national anthem: "Hen Wlad Fy Nhadau" (The Old Land of My Fathers):

> *Mae hen wlad fy nhadau yn annwyl i mi,*
> *Gwlad beirdd a chantorion, enwogion o fri;*
> *Ei gwrol ryfelwyr, gwladgarwyr tra mad,*
> *Dros ryddid collasant eu gwaed.*

Gwlad, gwlad, pleidiol wyf i'm gwlad.
Tra môr yn fur i'r bur hoff bau,
O bydded i'r hen iaith barhau.

The old land of my fathers is dear to me,
A nation of bards and singers, famous ones of renown;
Her brave warriors, the finest patriots,
For freedom they shed their blood.
Nation, nation, I will be true to my nation.
While the sea is a wall to the pure, beloved land,
O let the old language endure.

The 20th century saw Welsh literature stretch in new directions, through the works of such poets as D. Gwenallt Jones and T.H. Parry-Williams. The First World War brought with it Eisteddfod y Gadair Ddu (the Eisteddfod of the Black Chair): in 1917 the nation learned that Hedd Wyn, who was awarded the chair for his epic poem "Yr Arwr" (The Hero), had tragically been killed in action mere weeks before. His story was memorialized in an eponymous 1992 film (also see Figure 3 in Chapter 1).

One modern bard of great reputation, whose work reaches into the 21st century, is the late Gerallt Lloyd Owen (d. 2014). His poem "Fy Ngwlad" (My Country) is justly admired for its technical excellence, its stunning use of *cynghanedd*, and its visceral outrage. Its first verse addresses the memory of Llywelyn Fawr with a furious lament:

Wylit, wylit, Lywelyn
Wylit waed pe gwelit hyn.
Ein calon gan estron ŵr,
Ein coron gan goncwerwr,
A gwerin o ffafrgarwyr
Llariaidd eu gwên lle'r oedd gwŷr.

You would weep, you would weep, Llywelyn
You'd weep blood if you were to see this.
Our heart with a foreigner,
Our crown with a conqueror,
And a people of favour-curriers
With docile smiles where once were men.

The repetition of consonants in the last line, in particular, gives a supreme example of *cynghanedd* (see Chapter 2 for more about this Welsh poetic device).

Less militant and more romantic is the anonymous poem "Mi gerddaf gyda thi" (I'll walk with you). It has been sung by multiple 20th-century artists and is often read in Welsh-language wedding ceremonies:

> *Mi gerddaf gyda thi dros lwybrau maith,*
> *A blodau, cân a breuddwyd ar ein taith;*
> *I'th lygaid syllaf i a dal dy law:*
> *Mi gerddaf gyda thi, beth bynnag ddaw.*

> I'll walk with you over long paths,
> And flowers, a song and a dream on our journey;
> I'll gaze into your eyes and take your hand:
> I'll walk with you, whatever comes.

The bardic tradition is at the core of Welsh identity. It is of utmost and continuing importance to the language. As you consider the possibilities for a Welsh tattoo, you may find great inspiration by exploring this heritage, including the works of the poets mentioned above and many others.

Contemporary Welsh Music

Contemporary Welsh music offers enjoyment and inspiration to anyone with an interest in the Welsh language. Popular music in Welsh spans many genres, including pop, rock, folk, rap, and country. Welsh-language radio (BBC Radio Cymru and Radio Cymru 2) plays a wide range of Welsh music, and the National Eisteddfod stages an enormous number of live concerts and competitions during the festival each year. Live music at venues large and small is a prominent part of Welsh culture.

Contemporary Welsh music has given the world some big names, among them such well-known voices as Shirley Bassey, Charlotte Church, Katherine Jenkins, Tom Jones, and Bryn Terfel. Many

others have not found crossover success, particularly those who perform mostly or solely in Welsh, but they enjoy fame within Wales nonetheless. A newcomer to contemporary Welsh music can begin by listening to Radio Cymru online, or exploring music videos by Welsh artists on YouTube and online streaming services.

For those seeking inspiration for a Welsh tattoo, the contemporary folk scene offers a fruitful entry point. Traditional instruments such as the Welsh harp continue to figure prominently, but Welsh folk musicians have also applied their keen eyes and sharp wit to write lyrics combining deep patriotism with biting social commentary. The entire scene owes an incalculable debt to Dafydd Iwan, whose career crossed over from folk music to politics in the 1960s and 70s. In retrospect this seems like an exceptionally Welsh thing to happen.

Among Dafydd Iwan's gifts to Wales is his patriotic folk song, "Yma o Hyd" (Still Here). It has become something of an unofficial national anthem, and celebrates the determination of the Welsh people to survive and prosper in the face of great challenges, including to their own cultural identity and language. It even made a comeback in January 2020 to top the UK iTunes song chart in connection with a campaign by YesCymru, a Welsh independence movement group. One could do much worse for a tattoo than to simply borrow the song's well-known chorus:

Er gwaetha pawb a phopeth, ry'n ni yma o hyd.

Despite everyone and everything, we're still here.

Another example of social commentary by the folk scene comes from the group Plethyn. Their song "Tân yn Llŷn" (Fire in Llŷn) recalls a famous protest in 1936. The trouble started when a Royal Air Force bombing school was set to be established on the Llŷn peninsula in northwest Wales, after two proposed locations in England met with public protests. The Welsh public protested as well, not least because the planned site was historically and culturally significant, but the government refused to listen. Subsequently, three men set fire to the bombing school and promptly turned themselves in. After nine months in prison, they returned home as heroes.

The song "Tân yn Llŷn" looks back at these events and, in the refrain, asks a potent question:

> *Beth am gynnau tân fel y tân yn Llŷn?*
> *Tân yn ein calon a thân yn ein gwaith,*
> *Tân yn ein crefydd a thân dros ein hiaith?*

> What about lighting a fire like the fire in Llŷn?
> Fire in our heart and fire in our work,
> Fire in our religion and fire for our language?

With such a diverse collection of artists working in contemporary Welsh music, spanning the full range of musical styles and perspectives, exploring Welsh music is a rich opportunity to expand your connection with Welsh culture and to find inspiration for a tattoo to cherish.

Hiraeth

Hiraeth refers to a culturally prominent Welsh concept related to a sense of longing. It has probably been analyzed to the point that almost too much has been said about it. Nevertheless, it is culturally prominent for a reason, and the desire for a Welsh tattoo is itself a clear modern expression of *hiraeth*.

It has been said that *hiraeth* lacks an English translation, which is perhaps overstating the case, but it is true that words like "homesickness" and "nostalgia" do not fully capture its meaning. The purest *hiraeth* undoubtedly has Wales as its object: the yearning for it, the connection with it, the love for its people and its language and its heartbreakingly beautiful landscape. But, as many have said in one way or another, to love is also to open yourself to the possibility of pain.

If you've traveled to or lived in many different places, you may be familiar with the feeling of a place laying claim to a piece of your heart. From then on, that part of you is only content in that place. Wherever you go, wherever else you feel at home, that part of you

will still be out of place, longing to be in its proper home, even somewhere it may never return to again.

The closest approach to *hiraeth* may come in considering the relationship between two familiar, but quite different, adages: "There's no place like home" and "You can't go home again."

A powerful example of the intersection between *hiraeth*, history, and politics is found in North Wales, where there is a body of water called Llyn Celyn. The word *llyn* means lake, but this one is a man-made reservoir. In 1957 an Act of Parliament approved a plan to create it in order to meet the growing water needs of the English city of Liverpool— at the cost of drowning the Welsh-speaking village of Capel Celyn in the Tryweryn river valley. Because it was an Act of Parliament, the normal planning process was circumvented, meaning that the objections of the Welsh people who would have their homes destroyed had no official standing. No Welsh Member of Parliament voted in support of the bill, and members of the community fought to preserve their homes for eight more years, but in 1965 the valley was flooded. Homes, farms, and even a cemetery were all submerged under more than one hundred feet of water.

Memorials have been built. Apologies have been issued. Songs have been written. And to this day graffiti artists in Wales remind us all:

Cofiwch Dryweryn.

Remember Tryweryn.

Chapter 4
Tattoos Lost in Translation

Now it's time to address your greatest fear: a bad Welsh tattoo. This might even be why you purchased this book. Don't worry! We're here to help. In this chapter, we'll discuss examples of Welsh tattoo translations gone wrong, so you can get it right.

Alive and Laughing?

The sentiment has appeared on throw pillows, jewelry, inspirational artwork, wallpaper trim … why not a tattoo? "Live, Laugh, Love." What could possibly go wrong with such a timeless suggestion to focus on what's important?

The tattoo depicted in Figure 13 says *Fyw, Chwerthin, Cariad.* Each of these words bears some relation to its counterpart in the original English "Live, Laugh, Love." Unfortunately, the combination of these three words in Welsh does not produce the intended effect. Instead, it comes out sounding more like "Alive, Laughing, Lover." How did this simple, popular English expression go off the rails in translation?

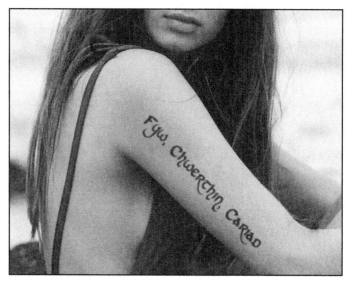

Figure 13: *Fyw, Chwerthin, Cariad,* **an incorrect Welsh tattoo translation**

When we reflect on the sense of the original "Live, Laugh, Love," which one of the following is closest to what we mean?

1. "To Live, to Laugh, to Love."
2. "Living, Laughing, Loving."
3. "Live! Laugh! Love!"

The third choice seems to be the closest to the desired meaning. The English expression uses imperative verbs, a form which is used to order, request, or advise. This particular saying is not an order, but it's definitely advice! It's a suggestion or reminder to you, the reader, to take those actions.

The real-life Welsh tattoo depicted in the illustration above also has three words—but unfortunately they don't quite go together! The first word is *fyw*, which does come from the word *byw*, meaning "living" or "to live." The trouble is that *fyw* is the soft-mutated form of *byw*, and the reasons why *byw* would soft mutate tend to imply that *fyw* is an adjective, as in *draig fyw* (a living dragon) or *yn fyw* (alive).

The second word in this tattoo, *chwerthin,* means "laughing" or "to laugh." Unlike the first word, this one is technically correct as a stand-alone word. But it's not an order or suggestion in the imperative like the English is; that would be *chwarddwch.*

The third word, *cariad,* is the Welsh equivalent of the English noun "love," as in "love is patient, love is kind." It can also refer to a romantic partner—a boyfriend, a girlfriend, or a lover is a *cariad.* What's more, *cariad* can also be used as a term of endearment, a pet name to refer to someone affectionately, as in "Hello, Love!"

Cariad is a common and versatile word in Welsh. But it is a noun that refers to a thing, not a verb that refers to an action. It is not the equivalent of the English verb "love," as in "Do you love me?" The Welsh verb meaning "to love" is *caru.* The imperative verb form, "love" as in "Love one another!" would be *carwch* (more polite) or *cara* (more familiar).

If what we want is the equivalent of "Live, Laugh, Love" in Welsh, then we need three verbs in a row in Welsh. This is what your high school English teacher would call "parallelism." However, only one of the Welsh words in this tattoo is a verb. The tattoo owner probably used a free translation website. But when they input the English expression with three verbs, they got a Welsh "translation" with an adjective ("alive"), a verb ("to laugh"), and a noun ("lover"). This happened because the free translation website wasn't programmed to distinguish between the adjective "live" and the verb "live," the noun "laugh" and the verb "laugh," or the noun "love" and the verb "love" in English. It could not handle the ambiguity of two words that are spelled identically, but have different functions and meanings.

There are two more issues here to touch on briefly. One is that even if you wanted to have an accurate, literal Welsh translation of the phrase, the imperative in Welsh sometimes feels stronger than it does in English. Imagining all three of these words in that form feels rather like typing an email in ALL CAPS—it's shouty! So to be honest, you might want to choose a different phrase altogether in Welsh. The other issue is that *byw,* "to live," is a defective verb that can't be written in the imperative anyway—but that's an issue for a grammar book!

So, the correct translation is *Byw, Chwerthin, Caru* (To Live, to Laugh, to Love). But to be honest, it doesn't have the punchiness of the English original. A better idea might be to adapt the sentiment in a different form. For example, we've seen another version in Welsh that is also familiar in English, and which seems to work much better: *Byw'n dda, chwerthin yn aml, caru'n fawr* (Live well, laugh often, love much). But if that's too long for you, at least *Byw, Chwerthin, Caru* isn't wrong!

Freedom Doesn't Come for Free

The desire for freedom is not an uncommon nationalist sentiment, and a tattoo proclaiming "Free Wales!" in Welsh is a positive sentiment for many Welsh patriots. Unfortunately the owner of the tattoo represented in Figure 14 has made a tragic error—the tattoo

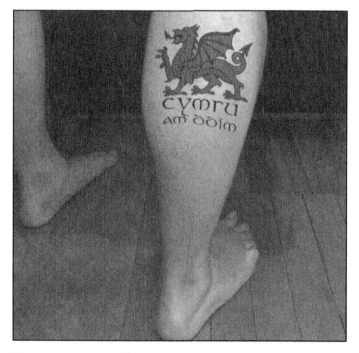

Figure 14: *Cymru am ddim,* **an incorrect Welsh tattoo translation**

says *Cymru am ddim,* which means "Wales for free"! This tattoo is clearly the result of looking up "Free Wales" on a free translation website.

What went wrong here in grammatical terms? The problem lies in the difference between two senses of the word "free," one associated with freedom, and the other with receiving something free of charge. In English, both of these senses can be expressed by one word, "free." But in Welsh, they are expressed by two different terms.

The Welsh expression *am ddim* means "free" as in "free of charge," not as in "freedom." In fact, it literally means "for nothing"! The proper word for a free Wales, a Wales living independently from British rule, would be *rhydd.*

In addition, since *Cymru* is a feminine noun, *rhydd* would soft-mutate to *rydd* (see Ch. 2, p. 16 for an explanation of mutation). So the proper tattoo would be *Cymru rydd!* (A free Wales!)

Unfortunately our misguided example is walking around with a permanent advertisement. Free to a good home: one Wales, used.

My Furry Friend

Fy ffrind, Fy calon. My friend, my heart. A worthy tribute to a four-legged loved one, and the individual Welsh words are correct. But there are two unfortunate lapses here: one a missed mutation, and one a missed opportunity for mutation and alliteration.

First off, the first-person possessive "my" (*fy*) causes nasal mutation. Thus, in the expression "my heart," *calon* changes to *nghalon.* Properly, "my heart" in Welsh is *fy nghalon*, and this tattoo should say *Fy ffrind, fy nghalon.* That's the mutation error.

What about the missed opportunity? Welsh has coexisted with English for so long, and indeed has been under siege by English for so long, that it has inevitably acquired a lot of borrowed vocabulary. You will often hear people speaking Welsh sprinkled with English words, which is one aspect of the broader phenomenon

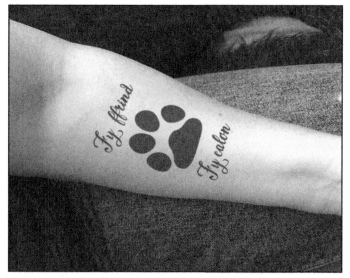

Figure 15: *Fy ffrind, Fy calon,* **a Welsh tattoo translation with a mistake and a missed opportunity**

known as "Wenglish." Sometimes a Welsh speaker will even use a Welsh word one time and an English equivalent the next time, sometimes almost in the same breath. It just happens naturally for some bilingual speakers.

As it happens, the Welsh word *ffrind* is an old borrowing from English—an adaptation of the word "friend." But Welsh does have another word for "friend," an even older word that was not derived from English, and therein lies the missed opportunity.

The other word for "friend" is *cyfaill.* Like the word *calon,* it starts with the letter *c,* and as we already mentioned, this *c* sound will nasally mutate to *ngh* after the possessive *fy.* Now, remember how fond the Welsh language is of consonant repetition? (See the section on *cynghanedd* in Ch. 1). If the word *cyfaill* is used in this tattoo expression instead of the English loanword *ffrind,* then both of the words after "my" will start with *c, cyfaill* and *calon,* and the mutation will be applied to both. The resulting phrase *fy nghyfaill, fy nghalon* truly rolls off the tongue. It even has a poetic sound to it that "my friend, my heart" in English does not. The improved

Welsh actually elevates the sentiment of the tattoo. So it's a little bit heartbreaking to see this poetic opportunity go to waste, ending up with the slightly Wenglish flavour of *Fy ffrind, fy nghalon*.

A Beautiful Secret in Plain Sight

The Wales Millennium Centre is a well-known performance venue in Cardiff, notable for its stunning modern architecture and the Welsh and English inscription that dominates its facade (see Figure 16). Fans of UK pop culture may also recognize it as a setting for the popular drama "Torchwood," and a location in "Doctor Who." It is a lovely work of art. Some people have designed beautiful tattoos with this inscription. But if you're going to use it for a tattoo inspiration, there's something you should know.

The English part of the inscription reads: "In these stones horizons sing." Heady stuff. The Welsh part reads: *Creu gwir fel gwydr o ffwrnais awen*. Equally heady—but also markedly different in meaning.

The poet who composed these lines for the Millennium Centre, Gwyneth Lewis, has explained that she didn't want the English to be a mere translation of the Welsh. She wanted to compose different lines in the two languages, which would each bear their own significance. If you knew nothing of Welsh, you might never be aware of this fact. It is a beautiful, open secret that the building shares with its Welsh-speaking admirers.

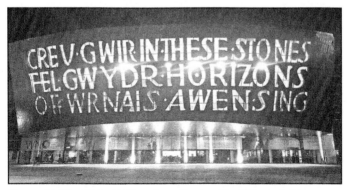

Figure 16: The Wales Millennium Centre, Cardiff, at night

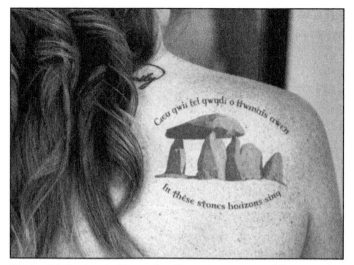

Figure 17: *Creu gwir fel gwydr o ffwrnais awen,* **a Welsh tattoo that is not a translation of the English**

So, what does that Welsh inscription mean? A common, and correct, interpretation is: "Creating truth like glass in the furnace of inspiration." But let's also acknowledge that *awen* isn't just inspiration. In fact Welsh has a word for inspiration that, like its English counterpart, derives from Latin: *ysbrydoliaeth.* But the Welsh word *awen* is most concerned with poetic inspiration, artistic inspiration, and when personified becomes a figure like that of "the muse."

Figure 17 shows a possible tattoo design which uses the whole inscription. Unfortunately it focuses only on the reference to stones in the English part, using an image of the Pentre Ifan cromlech in Pembrokeshire, Wales. This is a wonderful symbol of Wales's ancient past, but it only illustrates the English inscription.

There isn't just a single thought here. There are two unique, poetic thoughts, beautifully expressed in two different languages, dancing together on the face of the Millennium Centre. And isn't that an important thing to know if you decide to get a tattoo of them?

> *Creu gwir fel gwydr o ffwrnais awen.*
> In these stones horizons sing.

Chapter 5
Translation Tips

We've covered a lot of ground so far in this book. We've talked about the history and unique features of the Welsh language, the place it occupies in Welsh culture, ways to engage with Welsh language and culture today as you seek inspiration for a tattoo, and examples of errors and missed opportunities in Welsh tattoos. Now for the business at hand: when you've got your inspiration, what's next? If you aren't supposed to head straight to the English-Welsh dictionary or your favourite translation website—and we hope you've realized by now that we don't want you to try either of those things—then what are you supposed to do?

Translation Problems

Let's start by talking about some of the basic issues that confront the Welsh tattoo seeker. As you've gathered by now, the Welsh and English languages are very different. Just because something sounds good in English doesn't mean it will sound good in Welsh. Just because it makes sense in English doesn't mean it will make sense in Welsh.

This is because idioms and expressions are rooted in particular cultures. Take endearments, for example, the words and phrases we use to express love and affection. The Welsh endearments *cyw* or *blodyn tatws* sound perfectly natural and charming in Welsh, but the literal translations don't sound very endearing in English! The word *cyw* is literally "chick," a baby bird, which while it does have a familiar usage in English slang, nevertheless has a certain flippancy that is not associated with its use in Welsh. The expression *blodyn tatws* is literally "potato flower." Would you expect a significant other to call you their potato flower? By the same logic, you should not expect English expressions of endearment like "sweetheart," "pumpkin," or "baby" to translate directly into Welsh.

Speaking of babies, here's another good example: while in English you might see an adorable baby and exclaim, "Oh, how cute," in Welsh it would be perfectly unremarkable to exclaim, *"O, bechod!"* Literally: "Oh, sin!" That sounds odd to English ears, but it's just what some people say.

Similar to other Celtic languages, Welsh is wordy: a given passage of Welsh text will typically be visibly longer than its English equivalent. Much of this is simply down to grammar, which is one of the reasons that just looking up the words one by one in a dictionary is never the right thing to do. Also similar to the other Celtic languages, Welsh grammar is a long way from having been mastered by machine translation software, which means that the accuracy of what you get out of an online translator is also far from guaranteed, as we saw in the previous chapter.

Even if you've done good work to make sure something has been translated carefully, and the result is literally correct, it may just not sound right in Welsh. It can be helpful to ask yourself what you're really trying to say, and then to work with a Welsh speaker to discover how the Welsh language would address the same theme in its own way. The answer may be more different from English than you would expect.

This is a good reason for seeking inspiration from works already written in Welsh, such as songs and poems. If you find a verse or

a phrase that resonates with you, it doesn't matter if the English translation doesn't sound good, because in Welsh it sounds amazing! The odds are that you chose a line of Welsh poetry you liked because you saw an English translation of it, so the main thing is to be sure that the English translation you found is accurate. Translations provided by the artists themselves are of course the gold standard; an amateur translation that shows up in a blog post may be perfectly fine, but cannot always be taken at face value.

Translation Advice

Before you dive straight into the glossary in Chapter 6, please listen to some well-meaning advice. Every Welsh speaker alive wants you to have a good Welsh tattoo that you can be proud of. No one wants to see bad Welsh on display. People are fighting too hard to save the language for that. There is already so much bad Welsh out there (for example, on public signage), that a social media movement called Scymraeg has no shortage of terrible translations to mock. It would be a pity to add your new tattoo to the list.

When it comes to the glossary translations, it is extremely important to use them *exactly* as they are printed. Don't change anything about them. Don't alter the spelling, the punctuation, the accent marks, the word order, or anything else. Because of the different types of mutations and grammatical situations, the same word can be spelled different ways in different contexts. If you're thinking of changing or adapting something from the glossary, please seek help from a fluent Welsh speaker or even a professional translator, no matter how small of a change you think it is.

If you need a new translation into Welsh, either to adapt something from the glossary or because you've found inspiration elsewhere, please don't try to do it yourself as a non-Welsh speaker. A dictionary, online translator, or search engine cannot provide the help you need. Instead, you can reach out to knowledgeable Welsh speakers or professional translators online. Welsh is one of the most widely-spoken Celtic languages, with a relatively large number of native speakers. This works in your favour because you will be more likely to be able to find a qualified Welsh speaker to

help. Of course, Welsh also has a large number of learners, so you must be cautious about receiving less-than-expert advice online.

There are online groups and discussion forums for Welsh language learners and enthusiasts. Tattoo shops in Wales are on social media, too, and many of them will have fluent Welsh-speaking tattoo artists. You can and should seek knowledgeable help, and you should make sure any translation you receive is double-checked. However, don't be offended if tattoo translation isn't something an online group, forum, or person wants to engage with—particularly for free! Be a good online citizen. Among most Welsh speakers, your respect for the language and desire to "get it right" will be appreciated. If you are seeking a tattoo written in Literary Welsh (see Chapter 1) that is not listed in this book, a professional translator and/or academic will be your best bet.

If you think you've found inspiration in Welsh, for example in a song or poem, and you want to be certain you understand the meaning in English, there are ample resources at your disposal. As a non-Welsh speaker, it's perfectly reasonable to put a line in Welsh into an online translator just to see what comes out in English. Try looking up words in the dictionary. See what you can make of it! And then post questions in an online discussion forum. Ask in one of the Welsh language enthusiast groups if the line means what you think it does. Ask if someone can point you to an authoritative translation.

It's also worth thinking about whether your interest in Welsh can go beyond your tattoo. Perhaps you'll find, as you seek inspiration, that you're interested in learning some of the language. As different as Welsh is in comparison to English, one of the nice things about it for a learner is that you can gain useful amounts of Welsh fairly quickly. Dysgu Cymraeg (Learn Welsh) offers classes all over Wales and multiple online resources. Another popular resource is Say Something in Welsh, which aims to get people speaking in the dialect of their choice, North Walian or South Walian, as quickly as possible. You can also study Welsh on your phone using the Duolingo app. The organization Cymdeithas Madog offers Welsh learning opportunities in North America, and the North America-Wales Foundation offers scholarships to

study in Wales. See the "Resources" section at the end of this book for more information about all of these resources.

The community of Welsh speakers and learners is an admirably open and welcoming one. Despite the centuries of colonial oppression described in Chapter 1, more and more Welsh people now feel comfortable taking pride in the language, even if they don't speak it. Many people who feel that the language was taken from them or from their ancestors are deciding that now is the time to take it back. The Welsh government has set the challenge of growing the number of Welsh speakers to one million by the year 2050.

Maybe you can help.

Chapter 6
The Welsh Tattoo Glossary

The entries in this glossary have been compiled from many different sources, including internet discussion forums, songs, dictionaries, Welsh Bible translations, and lists of traditional Welsh proverbs.

How to Use the Glossary

The glossary contains over 400 words and phrases grouped into thematic categories, including both translations of popular English tattoo ideas and a number of native Welsh expressions. Within categories, entries are broadly arranged alphabetically, but thematic variations may take precedence.

The glossary reflects the broad range of interests and attitudes which commonly inform interest in possible tattoos. Remember that tattoos are personal; not every glossary entry will be relevant or appealing to every reader. What one person finds beautiful, another may find offensive. Please disregard entries that do not reflect your own values, beliefs, or preferences for your tattoo. The inclusion of an entry in the glossary does not imply endorsement by the authors or publisher.

How to Search

You can search the glossary in two ways. One way is to browse the categories to find ideas for a related theme, like "Place and Identity." The other is to browse the glossary index at the back of the book. In the index, every English word, phrase, or translation is listed alphabetically, followed by the unique number of the matching glossary entry or entries.

Format of Entries

Each entry follows the same format. First, the English word or phrase is given in **bold** type. The Welsh translation is given on the following line or lines in regular type. Additional information may be provided in *italics* to clarify parts of speech, meaning, or usage as required. Figure 18 gives a key to the information provided in italics in some of the glossary entries.

Abbreviation	Word	Meaning
sing.	singular	referring to only one person or object
pl.	plural	referring to more than one person or object
masc.	masculine	masculine gender
fem.	feminine	feminine gender
neutral	gender neutral	no particular gender
lit.	literally	exact word-for-word meaning
SW	South Walian dialect	Welsh dialect spoken in southern Wales
NW	North Walian dialect	Welsh dialect spoken in northern Wales

Figure 18: Glossary abbreviations

Some entries offer more than one possible translation or interpretation. Particularly in cases where an English expression lacks a single Welsh equivalent, multiple Welsh variations on the theme may exist. The literal meanings of each Welsh expression are provided in the glossary, so that you can choose the one that best suits your intent.

Gender Options

Some of the glossary entries that refer to people's jobs and roles have multiple gender options. This is because in Welsh, there are certain words that have different constructions depending on whether they are referring to a masculine person or a feminine person. Welsh can also construct some of these words in a way that does not specify the gender of the person; in other words, they are gender neutral. Wherever it is relevant and grammatical, the glossary entries provide masculine, feminine, and gender-neutral versions of terms, labeled as *masc.*, *fem.*, and *neutral*. Not all variants are in widely accepted use for all terms, which can limit the options. However, the options are sometimes different from English. For example, here are different words in Welsh for what to call a musical composer:

Cyfansoddwr – Composer *(masc.)*
Cyfansoddwraig – Composer *(fem.)*
Cyfansoddydd – Composer *(neutral)*

Pronouns

Unlike English, Welsh does not distinguish between subject and object pronouns, for example "she" and "her," or "they" and "them." However, Welsh still has a complex pronoun system. Figure 19 on the following page shows how commonly-encountered Welsh pronouns that you will see in the glossary can have different forms depending on dialect, register (Colloquial or Literary Welsh), or grammatical role in the sentence ("independent" or "conjunctive"). Other pronoun forms not shown in Figure 19 (such as *myfi* for "I/me" and *tydi* for "you") are sometimes used for emphasis, and appear in a few glossary entries. This complexity is a good

English Pronouns	Independent Pronouns			Conjunctive Pronouns
	Colloquial Welsh		Literary Welsh	
	North Walian	South Walian		
I/me	mi, fi, i			minnau, innau
you (familiar)	ti, chdi	ti		tithau
he/him	fo, o	fe, e	ef	yntau
she/her	hi			hithau
we	ni			ninnau
you (formal/plural)	chi		chwi	chwithau
they/them	nhw		hwy(nt)	(n)hwythau

Figure 19: Welsh pronouns

reminder of why "do it yourself" translation is a bad idea if you don't speak Welsh. The glossary gives the pronoun forms that are appropriate for each entry.

Spelling

There may be spelling differences among the variations for a given entry. Mostly these are due to the different forms of initial consonant mutation (see Chapter 2, p. 16). They are not mistakes; they are correct according to Welsh grammar.

Parts of speech

Where necessary to avoid confusion, some glossary entries are designated as a noun, adjective, or verb. These categories, known as "parts of speech," describe words by their function in a sentence. Nouns are words for people, places, or things; adjectives are

descriptive words; verbs are action words. In the glossary, for the entries composed of a series of individual words, such as "family, faith, forgiveness," we have taken care to ensure that all words are the same part of speech (for example, all nouns, or all verbs), as we discussed in Chapter 4. If you plan to combine your own selection of words into a single such series, be sure to do the same. Do not mix nouns, verbs, and adjectives in a list like this.

Capitalization

All glossary entries are capitalized for the sake of uniformity. Proper nouns (names of persons and places) are also capitalized, as the rules for this are the same in Welsh as in English. The capitalization of a tattoo is up to you. One of the following three options is recommended: 1) capitalize the first word and proper nouns only; 2) use all lower-case letters; or 3) use all upper-case or capital letters (i.e. ALL CAPS). Except for proper nouns, which are always capitalized, all lower-case or all upper-case is recommended for single words. Note also that Welsh does occasionally use different accent marks, and this is reflected in some of the glossary entries. It's not worth trying to catalog them all here, but it is very important not to omit these marks from your tattoo. They are an essential part of the correct spelling.

Bible Excerpts

Several glossary entries use phrases, verses, or excerpts from the Bible. These are drawn from the 1620 edition of the William Morgan translation.

Welsh Proverbs

This section lists a selection of traditional Welsh proverbs, or *diarhebion*. Many more exist than are included here. We have chosen a representative sample of proverbs that work well for expressing popular tattoo themes. If you are interested in exploring Welsh proverbs further, there are multiple sources online, though often without English translations.

The Welsh Tattoo Glossary

Place and Identity

1. **Heritage**
 Etifeddiaeth

2. **Homesickness** *(or nostalgia, or longing)*
 Hiraeth

3. **Lucky to be Welsh**
 Lwcus i fod o dras Gymreig *(lit. Lucky to be of Welsh descent)*
 Lwcus i fod yn Gymro *(masc., lit. Lucky to be a Welshman)*
 Lwcus i fod yn Gymraes *(fem., lit. Lucky to be a Welshwoman)*

4. **Wales**
 Cymru

5. **Wales, land of my heart**
 Gwlad fy nghalon yw Cymru

6. **Wales, love of my heart**
 Cariad fy nghalon yw Cymru

7. **Wales forever**
 Cymru am byth

8. **Free Wales**
 Cymru rydd

9. **I am Welsh**
 Rwyf o dras Gymreig *(lit. I am of Welsh descent)*
 Cymro ydwyf *(masc., lit. I am a Welshman)*
 Cymraes ydwyf *(fem., lit. I am a Welshwoman)*

10. **Welsh** *(the language)*
Cymraeg *(noun)*

11. **Welsh-American**
Americanwr o dras Gymreig *(noun, masc.)*
Americanes o dras Gymreig *(noun, fem.)*

12. **Welsh-Canadian**
Canadiad o dras Gymreig *(noun, neutral)*

13. **Welsh boy/man**
Bachgen o Gymru *(lit. Boy from Wales)*
Dyn o Gymru *(lit. Man from Wales)*
Hogyn o Gymru *(NW, lit. Man from Wales)*
Cymro *(lit. Welshman)*

14. **Welsh girl/woman**
Merch o Gymru *(SW, lit. Girl from Wales)*
Hogan o Gymru *(NW, lit. Girl from Wales)*
Dynes o Gymru *(SW, lit. Woman from Wales)*
Menyw o Gymru *(NW, lit. Woman from Wales)*
Cymraes *(lit. Welshwoman)*

15. **Welshness**
Cymreictod

16. **Land of my birth**
Gwlad fy ngeni

17. **Land of my heart**
Gwlad fy nghalon

18. **Land of my soul**
Gwlad f'enaid

19. **The old land of my fathers** *(from the Welsh national anthem)*
Hen wlad fy nhadau

20. **I am true to my country** *(from the Welsh national anthem)*
Pleidiol wyf i'm gwlad

21. **May the old language endure** *(from the Welsh national anthem)*
Bydded i'r hen iaith barhau

22. **The language of heaven** *(a poetic name for the Welsh language)*
Iaith y nefoedd

23. **Made in America of Welsh parts**
Gwnaed yn America o rannau Cymreig

24. **Made in the United States of Welsh parts**
Gwnaed yn yr Unol Daleithiau o rannau Cymreig

25. **Made in Canada of Welsh parts**
Gwnaed yng Nghanada o rannau Cymreig

26. **Made in Wales**
Gwnaed yng Nghymru

27. **My heart is in Wales**
Yng Nghymru mae fy nghalon

28. **Proud to be me**
Falch o fod yn fi fy hun

29. **Proud to be Welsh**
Falch o fod o dras Gymreig *(neutral)*
Cymro balch *(masc., lit. Proud Welshman)*
Cymraes falch *(fem., lit. Proud Welshwoman)*

30. **Dragon**
Draig

31. **The Red Dragon**
Y ddraig goch

32. **Child/Son/Daughter of the mountain**
Plentyn y mynydd *(Child of the mountain)*
Mab y mynydd *(Son of the mountain)*
Merch y mynydd *(Daughter of the mountain)*

33. **Child/Son/Daughter of the sea**
Plentyn y môr *(Child of the sea)*
Mab y môr *(Son of the sea)*
Merch y môr *(Daughter of the sea)*

34. **Child/Boy/Girl of Snowdon**
Plentyn yr Wyddfa *(Child of Snowdon)*
Hogyn yr Wyddfa *(NW, Boy of Snowdon)*
Hogan yr Wyddfa *(NW, Girl of Snowdon)*

35. **Tradition**
Traddodiad

36. **I speak Welsh**
Rwy'n siarad Cymraeg

37. **North Wales**
Gogledd Cymru

38. **South Wales**
De Cymru

39. **The Valleys**
Y Cymoedd

40. **Child/Son/Daughter of the Valleys**
Plentyn y Cymoedd *(Child of the Valleys)*
Mab y Cymoedd *(Son of the Valleys)*
Merch y Cymoedd *(Daughter of the Valleys)*
Crwt y Cymoedd *(SW, Boy of the Valleys)*
Croten y Cymoedd *(SW, Girl of the Valleys)*

Family

41. **Baby** *(infant)*
Baban

42. **My baby**
Fy maban

43. **Our baby**
Ein baban

44. **Brother/Brothers**
Brawd *(sing., Brother)*
Brodyr *(pl., Brothers)*

45. **My brother/My brothers**
Fy mrawd *(sing., My brother)*
Fy mrodyr *(pl., My brothers)*

46. **My dear/beloved brother**
F'annwyl frawd

47. **Brothers forever**
Brodyr am byth

48. **Older brother**
Brawd hŷn

49. **Oldest brother**
Brawd hynaf

50. **Middle brother**
Brawd canol

51. **Youngest/little brother**
Brawd ifancaf *(lit. Youngest brother)*
Brawd bach *(lit. Little brother)*

52. **My brother, my friend**
Fy mrawd, fy nghyfaill *(older word for friend)*
Fy mrawd, fy ffrind *(borrowed word for friend)*

53. **My brother, my best friend**
Fy mrawd, fy nghyfaill pennaf *(older word for* friend*)*
Fy mrawd, fy ffrind gorau *(borrowed word for* friend*)*

54. **Child**
Plentyn

55. **Children**
Plant

56. **My child/My children**
Fy mhlentyn *(My child)*
Fy mhlant *(My children)*

57. **Our child/Our children**
Ein plentyn *(Our child)*
Ein plant *(Our children)*

58. **My child is my world/My children are my world**
Fy mhlentyn yw fy myd *(sing., My child is my world)*
Fy mhlant yw fy myd *(pl., My children are my world)*

59. **My child is my life/My children are my life**
Fy mhlentyn yw fy mywyd *(sing., My child is my life)*
Fy mhlant yw fy mywyd *(pl., My children are my life)*

60. **My child is my everything/My children are my everything**
Fy mhlentyn yw fy mhopeth *(sing., My child is my everything)*
Fy mhlant yw fy mhopeth *(pl., My children are my everything)*

61. **Cousin/Cousins**
Cefnder *(sing. masc., Cousin)*
Cefndryd *(pl. masc. or mixed-gender, Cousins)*
Cyfnither *(sing. fem., Cousin)*
Cyfnitherod *(pl. fem., Cousins)*

62. **My cousin/My cousins**
Fy nghefnder *(sing. masc., My cousin)*
Fy nghefndryd *(pl. masc. or mixed-gender, My cousins)*
Fy nghyfnither *(sing. fem., My cousin)*
Fy nghyfnitherod *(pl. fem., My cousins)*

63. **Dad**
Dad

64. **Daddy's little girl**
Merch fach Dadi

65. **Daughter**
Merch

66. **Daughters**
Merched

67. **My daughter**
Fy merch

68. **My daughters/My girls**
Fy merched

69. **Our daughter/Our daughters**
Ein merch *(sing., Our daughter)*
Ein merched *(pl., Our daughters)*

70. **My beautiful daughter**
Fy merch hardd

71. **Two beautiful daughters**
Dwy ferch hardd

72. **Three beautiful daughters**
Tair merch hardd

73. **Four beautiful daughters**
Pedair merch hardd

74. **Family**
Teulu

75. **Family above all**
Teulu cyn dim *(lit. Family before everything)*

76. **Family first**
Teulu'n gyntaf

77. **Family forever**
Teulu am byth

78. **My family forever**
Fy nheulu am byth

79. **Family, faith, forgiveness**
Teulu, ffydd, maddeuant

80. **Father**
Tad

81. **My father**
Fy nhad

82. **My dear/beloved father**
F'annwyl Dad

83. **Fatherhood**
Tadolaeth

84. **My father's son**
Mab fy nhad

85. **His father's son**
Mab ei dad

86. **My father's daughter**
Merch fy nhad

87. **Her father's daughter**
Merch ei thad

88. **Granddaughter/Granddaughters**
Wyres *(sing., Granddaughter)*
Wyresau *(pl., Granddaughters)*

89. **Grandson/Grandsons**
Ŵyr *(sing., Grandson)*
Wyrion *(pl., Grandsons)*

90. **Grandfather/Grandfathers**
Tad-cu *(sing., SW, Grandfather)*
Taid *(sing., NW, Grandfather)*
Tad-cuod *(pl., SW, Grandfathers)*
Teidiau *(pl., NW, Grandfathers)*

91. **Grandmother/Grandmothers**
Mam-gu *(sing., SW, Grandmother)*
Nain *(sing., NW, Grandmother)*
Mam-guod *(pl., SW, Grandmothers)*
Neiniau *(pl., NW, Grandmothers)*

92. **My grandfather**
Fy nhad-cu *(SW)*
Fy nhaid *(NW)*

93. **My grandmother**
Fy mam-gu *(SW)*
Fy nain *(NW)*

94. **My dear/beloved grandmother**
F'annwyl fam-gu *(SW)*
F'annwyl nain *(NW)*

95. **My dear/beloved grandfather**
F'annwyl dad-cu *(SW)*
F'annwyl daid *(NW)*

96. **Honour thy father and thy mother** *(Exodus 20:12)*
Anrhydedda dy dad a'th fam

97. **Honour thy father**
Anrhydedda dy dad

98. **Honour thy mother**
Anrhydedda dy fam

99. **Mom/Mother**
Mam

100. **My mother**
Fy mam

101. **My dear/beloved mother**
F'annwyl fam

102. **Motherhood**
Mamolaeth

103. **Her mother's daughter**
Merch ei mam

104. **My mother's daughter**
Merch fy mam

105. **His mother's son**
Mab ei fam

106. **My mother's son**
Mab fy mam

107. **My mother and father**
Fy mam a'n nhad

108. **My parents**
Fy rhieni

109. **Sister/Sisters**
Chwaer *(sing., Sister)*
Chwiorydd *(pl., Sisters)*

110. **My sister/My sisters**
Fy chwaer *(sing., My sister)*
Fy chwiorydd *(pl., My sisters)*

111. **My dear/beloved sister**
F'annwyl chwaer

112. **Sisters forever**
Chwiorydd am byth

113. **Oldest sister**
Chwaer hynaf

114. **Middle sister**
Chwaer ganol

115. **Youngest sister**
Chwaer ifancaf *(lit. Youngest sister)*
Chwaer fach *(lit. Little sister)*

116. **Baby sister**
Chwaer fach *(lit. Little sister)*

117. **My sister, my friend**
Fy chwaer, fy nghyfaill *(older word for* friend*)*
Fy chwaer, fy ffrind *(borrowed word for* friend*)*

118. **My sister, my best friend**
Fy chwaer, fy nghyfaill pennaf *(older word for* friend*)*
Fy chwaer, fy ffrind gorau *(borrowed word for* friend*)*

119. **Son**
Mab

120. **My son**
Fy mab

121. **My sons**
Fy meibion

122. **My boys**
Fy mechgyn

123. **My handsome son**
Fy mab golygus

124. **Two handsome sons**
Dau fab golygus

125. **Three handsome sons**
Tri mab golygus

126. **Four handsome sons**
Pedwar mab golygus

Love and Friendship

127. **Eternal love**
Cariad tragwyddol

128. **Eternal**
Tragwyddol

129. **Faith, love, hope, happiness**
Ffydd, cariad, gobaith, hapusrwydd

130. **For my love**
I'm cariad

131. **Forever**
Am byth

132. **Forever and ever**
Yn oes oesoedd

133. **Friend** *(see Chapter 4, pp. 39–41)*
Cyfaill *(older word for* friend*)*
Ffrind *(borrowed word for* friend*)*

134. **My friend, my heart** *(see Chapter 4, pp. 39–41)*
Fy nghyfaill, fy nghalon

135. **Best friend/Best friends**
Cyfaill pennaf *(sing., Best friend, older word for* friend*)*
Cyfeillion pennaf *(pl., Best friends, older word for* friend*)*
Ffrind gorau *(sing., Best friend, borrowed word for*
 friend*)*
Ffrindiau gorau *(pl., Best friends, borrowed word for*
 friend*)*

136. **Friendship**
Cyfeillgarwch

137. **Friendship and kindness**
Cyfeillgarwch a charedigrwydd

138. **Husband/Wife/Spouse/Partner**
Gŵr *(Husband)*
Gwraig *(Wife)*
Priod *(Spouse)*
Cymar *(Partner)*

139. **Husband and wife**
Gŵr a gwraig

140. **Partners**
Cymheiriaid

141. **I am loved**
Myfi a gerir *(Literary Welsh)*

142. **I am my beloved's, and my beloved is mine** *(Song of*
Solomon 6:3)
Myfi wyf eiddo fy anwylyd, a'm hanwylyd yn
eiddof finnau

143. **I love you**
Rwy'n dy garu di

144. **Love**
Cariad

145. **Love is everything**
Cariad yw popeth

146. **Love is patient, love is kind** *(1 Corinthians 13:4)*
Y mae cariad yn hirymaros, yn gymwynasgar

147. **Lover**
Cariad

148. **My beloved**
Fy anwylyd

149. **My eternal love**
Fy nghariad tragwyddol

150. **My husband**
Fy ngŵr

151. **My wife**
Fy ngwraig

152. **My partner**
Fy nghymar

153. **My love**
Fy nghariad

154. **One flesh** *(Genesis 2:24)*
Un cnawd

155. **Only you in my heart**
Ti'n unig yn fy nghalon *(SW)*
Chdi'n unig yn fy nghalon *(NW)*

In Memoriam

156. **Forever**
Am byth

157. **Forever in my heart**
Yn fy nghalon am byth

158. **Broken-hearted**
Calon friw

159. **Everything that lives will die**
Bydd popeth sy'n byw yn marw

160. **Grief**
Galar

161. **Honour her memory**
Anrhydedder ei chof

162. **Honour his memory**
Anrhydedder ei gof

163. **Honour our ancestors**
Anrhydeddwn ein cyndeidiau

164. **Honour them**
Anrhydedder hwythau *(Literary Welsh)*

165. **In loving memory of *[name]***
Er cof annwyl am *[name]*

166. **In memory of *[name]***
Er cof am *[name]*

167. **In memoriam**
Er cof *(lit. In memory)*
Er cof amdano *(lit. In his memory)*
Er cof amdani *(lit. In her memory)*
Er cof amdanynt *(lit. In their memory)*

168. **In my heart**
Yn fy nghalon

169. **In my heart forever and always**
Yn fy nghalon am byth bythoedd

170. **Life and death**
Bywyd a marwolaeth

171. **Heavy heart, strong soul**
Calon drom, ysbryd cryf

172. **May he/she/they have peace**
Heddwch i'w lwch *(lit. Peace unto his dust/ashes)*
Heddwch i'w llwch *(lit. Peace unto her dust/ashes)*
Heddwch i'w llwch *(lit. Peace unto their dust/ashes)*

173. **Rest in peace**
Cwsg mewn hedd

174. **Still living in the hearts left behind**
Dal yn fyw yn y galon *(lit. Still alive in the heart)*

175. **Until we meet again**
Tan i ni gyfarfod eto

176. **Without you, my love**
Hebddot ti, fy nghariad

Religion and Spirituality

177. **Angel**
Angel

178. **Angels and demons**
Angylion a chythreuliaid

179. **In the arms of the angel**
Yng nghoflaid yr angel *(lit. In the angel's embrace)*

180. **Be still and know that I am God** *(Psalm 46:10)*
Peidiwch, a gwybyddwch mai myfi sydd Dduw

181. **Be still**
Ymlonyddwch

182. **Bless you**
Bendith arnat *(familiar)*
Bendith arnoch *(formal/plural)*

183. **Blessed**
Gwynfydedig

184. **Blessing**
Bendith

185. **By grace**
Trwy ras

186. **By the grace of God**
Trwy ras Duw

187. **Demon**
Cythraul

188. **Druid**
Derwydd

189. **Everlasting life**
Bywyd tragwyddol

190. **Evil**
Drwg *(adjective)*
Y fall *(noun)*

191. **Faith, hope, love**
Ffydd, gobaith, cariad

192. **God**
Duw

193. **Goddess**
Duwies

194. **Good and evil**
Drwg a da *(adjectives; lit. Evil and good)*

195. **Goodness**
Daioni

196. **Grace**
Gras

197. **Grace of God**
Gras Duw

198. **Heaven**
Nefoedd

199. **Hell**
Uffern

200. **Holy**
Sanctaidd

201. **Holy Spirit**
Yr Ysbryd Glân

202. **Jesus**
Iesu

203. **Jesus Christ**
Iesu Grist

204. **Lord, make me an instrument of your peace**
(Prayer of St. Francis)
Iôr, gwna fi'n offeryn dy hedd

205. **Magic**
Hud

206. **Mary**
Mair

207. **Only God**
Neb ond Duw *(lit. No one but God)*

208. **Pagan**
Pagan

209. **Paradise**
Paradwys

210. **Penitent**
Edifar

211. **Pray for us**
Gweddïwch drosom

212. **Repentance**
Edifeirwch

213. **Sacred**
Cysegredig

214. **Saint**
Sant *(masc.)*
Santes *(fem.)*

215. **Saint David**
Dewi Sant

216. **Sanctuary**
Noddfa

217. **Saved**
Achubedig

218. **Sinner**
Pechadur

219. **So mote it be**
Felly y byddo

220. **The Devil**
Y Diafol

221. **The Father, The Son, and The Holy Spirit**
Y Tad, y Mab, a'r Ysbryd Glân

222. **The Goddess**
Y Dduwies

223. **The Lord is my shepherd, I shall not want** *(Psalm 23:1)*
Yr Arglwydd yw fy mugail; ni bydd eisiau arnaf

224. **The truth against the world**
Y gwir yn erbyn y byd

225. **The Trinity**
Y Drindod

226. **Watch over me**
Gwarchod fi

227. **Witch**
Gwrach

Courage, Honour, and Service

228. **Conqueror**
Gorchfygwr

229. **Conquest**
Goruchafiaeth *(lit. Triumph)*

230. **Death before dishonour**
Gwell angau na gwarth *(lit. Better death than disgrace)*
Gwell angau na chywilydd *(lit. Better death than shame)*

231. **Death from above**
Angau o'r awyr *(lit. Death from the air)*

232. **Defender**
Amddiffynnwr *(masc.)*
Amddiffynwraig *(fem.)*
Amddiffynnydd *(neutral)*

233. **Follow me**
Dilynwch fi

234. **Hero**
Arwr

235. **Heroine**
Arwres

236. **Honour**
Anrhydedd

237. **Iron man**
Dyn haearn

238. **Keep the peace**
Cadw'r hedd

239. **My hero**
Fy arwr

240. **My soldier**
Fy milwr

241. **No fear**
Dim ofn

242. **No mercy**
Dim trugaredd

243. **Our hero**
Ein harwr

244. **Our soldier**
Ein milwr

245. **Patriot**
Gwladgarwr

246. **Protect and serve**
Amddiffyn a gwasanaethu

247. **Protector**
Noddwr *(masc.)*
Noddwraig *(fem.)*

248. **Second to none**
Heb ei ail *(masc.)*
Heb ei hail *(fem.)*

249. **Soldier/Soldiers**
Milwr *(sing., Soldier)*
Milwyr *(pl., Soldiers)*

250. **Vengeance**
Dial

251. **Victory**
Buddugoliaeth

252. **Warrior/Warriors**
Rhyfelwr *(sing. masc.)*
Rhyfelwraig *(sing. fem.)*
Rhyfelwyr *(pl., Warriors)*

Work, Activities, and Identities

253. **Artist**
Arlunydd *(visual artist)*
Crefftydd *(craftsperson)*

254. **Atheist**
Anffyddiwr *(masc.)*
Anffyddwraig *(fem.)*

255. **Athlete**
Athletwr *(masc.)*
Athletwraig *(fem.)*

256. **Bard**
Bardd

257. **Book-lover**
Llyfrgarwr

258. **Coal-miner**
Glöwr

259. **Coal-miner's son/daughter**
Mab glöwr *(Coal-miner's son)*
Merch glöwr *(Coal-miner's daughter)*

260. **Composer**
Cyfansoddwr *(masc.)*
Cyfansoddwraig *(fem.)*
Cyfansoddydd *(neutral)*

261. **Cook/Chef**
Cogydd *(masc.)*
Cogyddes *(fem.)*

262. **Dance**
Dawnsio *(verb)*
Dawns *(noun)*

263. **Dancer**
Dawnsiwr *(masc.)*
Dawnswraig *(fem.)*

264. **Doctor**
Meddyg

265. **Engineer**
Peiriannydd

266. **Firefighter**
Diffoddwr tân *(masc.)*
Diffoddwraig dân *(fem.)*

267. **Fisherman/Fisherwoman**
Pysgotwr *(masc.)*
Pysgotwraig *(fem.)*

268. **Gambler**
Gamblwr

269. **Gardener**
Garddwr *(masc.)*
Garddwraig *(fem.)*

270. **Harpist**
Telynor *(masc.)*
Telynores *(fem.)*

271. **Healer** *(person who heals or cures)*
Iachäwr

272. **Herbalist**
Llysieuydd

273. **Hunter**
Heliwr *(masc.)*
Helwraig *(fem.)*

274. **Immigrant**
Mewnfudwr

275. **Knitter/Weaver**
Gwëwr

276. **Mermaid**
Môr-forwyn

277. **Music**
Cerddoriaeth

278. **Musician**
Cerddor

279. **Nurse**
Nyrs

280. **Performer**
Perfformiwr *(masc.)*
Perfformwraig *(fem.)*

281. **Pilgrim**
Pererin

282. **Pirate**
Môr-leidr

283. **Poet**
Bardd

284. **Professor**
Yr Athro
Darlithydd *(lit. Lecturer)*

285. **Sailor**
Llongwr

286. **Scientist**
Gwyddonydd

287. **Singer**
Canwr *(masc.)*
Cantores *(fem.)*

288. **Stranger**
Dieithryn

289. **Surgeon**
Llawfeddyg

290. **Teacher**
Athrawes *(fem.)*
Athro *(masc.)*

291. **Vegan**
Figan

292. **Vegetarian**
Llysieuwr *(masc.)*
Llysieuwraig *(fem.)*

293. **Writer**
Ysgrifennwr *(masc.)*
Ysgrifenwraig *(fem.)*
Awdur *(lit. Author)*

Emotions, Qualities, and Concepts

294. **Alive**
Yn fyw

295. **Awake**
Effro

296. **Beauty**
Harddwch

297. **Beautiful**
Hardd

298. **Beautiful fighter**
Brwydrwr hardd

299. **Beautiful warrior**
Rhyfelwr hardd

300. **Bliss**
Gwynfyd

301. **Breath**
Anadl

302. **Breathe**
Anadler

303. **Confidence**
Hyder

304. **Destiny**
Tynged

305. **Dream** *(noun)*
Breuddwyd

306. **Drug-free**
Rhydd o gyffuriau

307. **Enough**
Digon

308. **Plenty**
Digonedd

309. **Faithful**
Ffyddlon

310. **Fate**
Ffawd

311. **Fool** *(noun)*
Ffŵl

312. **Foolish**
Ffôl

313. **Free** *(adj.)*
Rhydd

314. **Freedom**
Rhyddid

315. **Good fortune**
Ffawd dda

316. **Good luck**
Pob lwc

317. **Happiness**
Hapusrwydd

318. **Hate**
Casineb

319. **Healing**
Iacháu

320. **Infinity**
Anfeidredd

321. **Joy**
Llawenydd

322. **Justice**
Cyfiawnder

323. **Laughter**
Chwerthin

324. **Life**
Bywyd

325. **Live, laugh, love**
Byw, chwerthin, caru *(lit. translation, but see Ch. 4)*
Byw'n dda, chwerthin yn aml, caru'n fawr *(lit. Live well, laugh often, love much)*

326. **Little by little**
Cam wrth gam *(lit. Step by step)*

327. **Me too**
Fi hefyd

328. **Mighty**
Cadarn

329. **No regret/No regrets**
Heb edifar *(lit. Without regret)*

330. **Peace**
Heddwch

331. **Pride**
Balchder

332. **Rainbow**
Enfys

333. **Sacrifice**
Aberth

334. **Strength**
Cryfder

335. **Strong**
Cryf *(masc.)*
Cref *(fem.)*

336. **Success and luck**
Lwc a llwyddiant *(lit. Luck and success)*
Ffawd a ffyniant *(lit. Fortune and prosperity)*

337. **Take a break**
Cymer hoe

338. **Truth**
Gwir

339. **Unafraid**
Heb ofn *(lit. Without fear)*

Personal Mottos and Sayings

340. **Black Lives Matter**
Bywydau Du o Bwys

341. **Dance as if no one is watching**
Dawnsier fel pe bai neb yn gwylio

342. **Don't forget to breathe**
Paid ag anghofio anadlu

343. **Don't worry**
Paid â phoeni *(NW)*
Paid becso *(SW)*

344. **Dream for the ages, live for today**
Breuddwydio am yr oesoedd, byw am heddiw

345. **Everything happens for a reason**
Mae rheswm i bopeth *(lit. There's a reason for everything)*

346. **Hold your ground/Stand your ground**
Dal dy dir

347. **I am myself**
Fy hunan ydwyf *(Literary Welsh)*

348. **I came, I saw, I conquered**
Deuthum, gwelais, gorchfygais *(Literary Welsh)*

349. **I'm living in the moment**
Rwy'n byw yn y foment

350. **Keep at it!**
Dal ati!

351. **Keep calm**
Gan bwyll

352. **Love as if you've never been hurt**
Car fel un nas clwyfwyd *(Literary Welsh)*

353. **Live every day as if it were your last**
Dylid byw bob dydd fel pe bai'r un olaf

354. **Live life to the fullest**
Dylid byw bywyd i'r eithaf

355. **Live to ride; ride to live**
Byw i farchogi; marchogi i fyw

356. **Never give up**
Paid byth ag ildio

357. **Nevertheless, she persisted**
Eto i gyd, hithau a barhaodd

358. **No Fear**
Dim ofn

359. **Only God can judge me**
Neb ond Duw all fy marnu

360. **Seize the day/Carpe diem**
Dal ar y cyfle *(lit. Take advantage of the opportunity)*
Cura'r haearn tra fo'n boeth *(lit. Strike the iron while it's hot)*
Y cyntaf i'r felin gaiff falu *(lit. The first to the mill gets to grind)*

361. **Sing as if no one is listening**
Cana fel pe bai neb yn gwrando

362. **That which does not kill me, makes me stronger**
Amynedd yw mam pob doethineb *(lit. Patience is the mother of all wisdom)*
Dim glaw Mai, dim mêl Medi *(lit. No May rain, no September honey)*
Ffawd ar ôl ffawd a wna ddyn yn dlawd *(lit. Fortune after fortune makes a man poor)*
Gwell yr heddwch gwaethaf na'r rhyfel gorau *(lit. Better the worst peace than the best war)*

363. **This too shall pass**
Daw hyn hefyd i ben *(lit. This too will come to an end)*
Eli i bob dolur yw amynedd *(lit. Patience is a balm to every sorrow)*

364. **What goes around, comes around**
Hen bechod a wna gywilydd newydd *(lit. An old sin makes a new shame)*

365. **YOLO** *(You only live once)*
Dim ond unwaith yr ydych ar y ddaear *(lit. You are only on the earth once)*
Nid eir i Annwn ond unwaith *(lit. One only goes to the underworld once)*

Quotes from Popular Culture and Song

366. **There's no place like home**
Does unman fel cartre

367. **Somewhere over the rainbow**
Rhywle draw dros yr enfys

368. **Remember Tryweryn**
Cofiwch Dryweryn

369. **Live long and prosper** *(Star Trek)*
Byw'n hir a ffynnu

370. **The needs of the many outweigh the needs of the few (or the one)** *(Star Trek)*
Pwysicach yw anghenion y llu nag anghenion y rhai (neu'r un)

371. **May the force be with you** *(Star Wars)*
Bydded y grym efo chi *(NW)*
Bydded y grym gyda chi *(SW)*

372. **Not all those who wander are lost** *(J.R.R. Tolkien)*
Nid ar goll pob un ar grwydr

373. **A prayer for the wild at heart, kept in cages** *(Tennessee Williams)*
Gweddi dros galonnau gwylltion dan glo

Traditional Welsh Sayings and Proverbs

374. **To be a leader, be a bridge**
A fo ben, bid bont

375. **The truth is the death of the guilty**
Angau'r euog ydyw'r gwir

376. **Hope is a secure anchor**
Angor diogel yw gobaith

377. **Every man is little, who thinks himself great**
Bach pob dyn a dybio ei hun yn fawr

378. **Everything that can be had in this world is only borrowed for a short time**
Benthyg dros amser byr yw popeth a geir yn y byd hwn

379. **Home is home, poor though it be**
Cartref yw cartref, er tloted y bo

380. **A nation without a language is a nation without a heart**
Cenedl heb iaith, cenedl heb galon

381. **Sun will come again on a hill** *(meaning It will get better)*
Daw eto haul ar fryn

382. **Persistent tapping breaks the stone**
Dyfal donc a dyr y garreg

383. **The fount of all misfortune is laziness**
Ffynnon pob anffawd, diogi

384. **A great sin can come through a small door**
Gall pechod mawr ddyfod trwy ddrws bychan

385. **The best knowledge is to know yourself**
Gorau adnabod, adnabod dy hun

386. **Better enough than too much**
Gwell digon na gormod

387. **Better to bend than to break**
Gwell plygu na thorri

388. **Do good to evil and hell won't take you**
Gwna dda dros ddrwg, uffern ni'th ddwg

389. **Do the little things**
Gwnewch y pethau bychain

390. **Easier said than done**
Haws dweud na gwneud

391. **Without God, nothing; with God, enough**
Heb Dduw, heb ddim; â Duw â digon

392. **One without fault was never born**
Heb ei fai, heb ei eni

393. **Practice makes perfect**
Meistr pob gwaith yw ymarfer *(lit. Practice is the master of all work)*

394. **There's a reward in every goodness**
Mewn pob daioni y mae gwobr

395. **The greater the hurry, the greater the obstacles**
Mwyaf y brys, mwyaf y rhwystr

396. **One cannot buy respect**
Ni ellir prynu parch

397. **All that glitters is not gold**
Nid aur yw popeth melyn *(lit. Everything yellow is not gold)*

398. **From wealth comes worry**
O gyfoeth y daw gofid

399. **The best scarcity is scarcity of words**
Prinder gorau, prinder geiriau

400. **You have to crawl before walking**
Rhaid cropian cyn cerdded

401. **A sword's praise is its idleness**
Segurdod yw clod y cledd

402. **Fair it is to look towards home**
Teg yw edrych tuag adref

403. **Three tries for a Welshman** *(meaning Nobody has to get it right on the first try)*
Tri chynnig i Gymro

404. **One lie is father to a hundred**
Un celwydd yn dad i gant

405. **The work praises the worker**
Y gwaith a ganmol y gweithiwr

406. **The truth against the world**
Y gwir yn erbyn y byd

407. **There's a black sheep in every flock**
Y mae dafad ddu ym mhob praidd

408. **The guilty flees without being chased**
Yr euog a ffy heb ei erlid

409. **The old know, the young surmise**
Yr hen a ŵyr, yr ifanc a dybia

Resources

Translation Assistance

Cymdeithas Cyfieithwyr Cymru (Association of Welsh Translators and Interpreters)
https://www.cyfieithwyr.cymru/en/
The professional association for Welsh translators, with a portal for finding translation assistance.

Welsh Language Learning Resources

Cymdeithas Madog, the Welsh Studies Institute in North America
www.madog.org, www.speakwelsh.org
A long-standing non-profit organization dedicated to providing Welsh language learning opportunities to people in North America.

Duolingo
https://www.duolingo.com
An online language-learning tool for self-guided study of many languages, including Welsh.

Dysgu Cymraeg (Learn Welsh)
https://learnwelsh.cymru
An array of Welsh learning opportunities sponsored by the Welsh government.

North America Wales Foundation
http://www.nawf.wales
A non-profit foundation working to promote cultural and educational links between North America and Wales. Offers scholarships to study Welsh.

Say Something in Welsh
https://www.saysomethingin.com/welsh
A popular online learning tool that encourages people to get started speaking Welsh in either North Walian or South Walian dialect.

Recommended Reading

Davies, John, *A History of Wales*. London, Penguin Books, 2007.
An in-depth and authoritative popular history of Wales, from ancient times to the present day.

Davies, Sioned, *The Mabinogion*. Oxford, Oxford University Press, 2007.
A good-quality English translation of Welsh mythology.

Hopwood, Mererid, *Singing in Chains: Listening to Welsh Verse*. Llandysul, Gomer Press, 2004.
An exploration of *cynghanedd* in Welsh poetry, for an English-speaking audience.

Jobbins, Siôn T., *The Phenomenon of Welshness*. Llanrwst, Gwasg Carreg Gwalch, 2011.
A pithy look at modern Welsh culture, national identity, and Welsh language activism.

Glossary Index

flock 407
follow 233
fool 311
foolish 312
force 370
forever 7, 47, 77, 78, 112, 131,
 132, 156, 157, 169
forget 342
forgiveness 79
fortune 315, 362
fount 383
four 73, 126
free 8, 313
freedom 314
friend 52, 53, 117, 118, 133,
 134, 135
friendship 136, 137
fullest 354

G

gambler 268
gardener 269
girl 14, 34, 40, 64
girls 68
give up 356
glitters 397
God 180, 186, 192, 197, 207,
 359, 391
Goddess 193, 222
goes 364
gold 397
good 194, 315, 316, 388
good fortune 315
good luck 316
goodness 195, 394
grace 185, 186, 196, 197
granddaughter 88
granddaughters 88
grandfather 90, 92
grandfathers 90

grandmother 91, 93, 94
grandmothers 91
grandson 89
grandsons 89
great 377, 384
greater 395
grief 160
grind 360
ground 346
guilty 375, 408

H

handsome 123, 124, 125, 126
happens 345
happiness 129, 317
harpist 270
hate 318
healer 271
healing 319
heals 271
heart 5, 6, 17, 27, 134, 155, 157,
 168, 169, 171, 373, 380
hearts 174
heaven 22, 198
heavy 171
hell 199, 388
herbalist 272
heritage 1
hero 234, 239, 243
heroine 235
hill 381
hold 346
holy 200, 201, 221
Holy Spirit 201, 221
home 366, 379, 402
homesickness 2
honey 362
honour 96, 97, 98, 161, 162,
 163, 164, 236
hope 129, 191, 376

hot 360
hundred 404
hunter 273
hurry 395
hurt 352
husband 138, 139, 150

I

idleness 401
immigrant 274
infinity 320
instrument 204
iron 237, 360

J

Jesus 202, 203
joy 321
judge 359
justice 322

K

keep 238, 350, 351
kept 373
kill 362
kind 146
kindness 137
knitter 275
know 180, 385, 409
knowledge 385

L

land 5, 16
language 21, 22, 380
last 353
laugh 325
laughter 323
laziness 383
leader 374
lecturer 284
left behind 174
lie 404

life 59, 170, 189, 324, 354
listening 361
little 51, 64, 326, 377, 389
live 325, 344, 353, 354, 355,
 365, 369
lives 159, 340
living 174, 349
long 369
longing 2
look 402
lord 204, 223
lost 372
love 127, 129, 130, 143, 144,
 145, 146, 149, 153, 176,
 191, 325, 352
loved 141
lover 147
loving 165
luck 316, 336
lucky 3

M

made 23, 24, 25, 26
magic 205
man 13, 238, 362, 377
many 371
Mary (mother of Jesus) 206
master 393
matter 340
may 219
May 362
me 28, 327
Me Too 327
meet 175
memoriam 167
memory 161, 162, 165, 166
mercy 242
mermaid 276
middle 50, 114
mighty 328

Other titles in the
TATTOO HANDBOOK SERIES

More titles from **bradan press**

Translations of Rumi
and other Scottish
Gaelic poetry
collections

Fionn MacCool
and other tales of
Celtic mythology
& folklore

The Scottish Gaelic
translation of *Anne
of Green Gables*
and more

Printed in Great Britain
by Amazon

79134168R00068